SWEAR WORDS
Adult Coloring Book
Series, Book II

Zelda Selby

©Copyrighted Material
A Ladies Image Publishing
admin@myamazonauthor.com

Dear Coloring Enthusiast,

Thank you so much for choosing my book. I know you will completely enjoy coloring these beautiful pages.

When coloring, it is very helpful if you place thicker paper or card behind the page. This helps with bleed-through and also helps you stay focused on that page's art.

Whether you purchased this coloring book or were given the book as a gift you will find coloring very beneficial in many different ways. Regardless of the reasons behind starting this fun and relaxing hobby you will soon see that you are reaping several mental health benefits.

Some of those benefits include experiencing a stronger sense of focus, and a more finely tuned sense of vision and motor skills. In the end , no matter why you choose to take up coloring as an adult, you will find yourself training your brain and fine tuning your mental clarity, while at the same time placing yourself in a wonderfully relaxed state.

Enjoy,

Zelda Selby

Blank Page

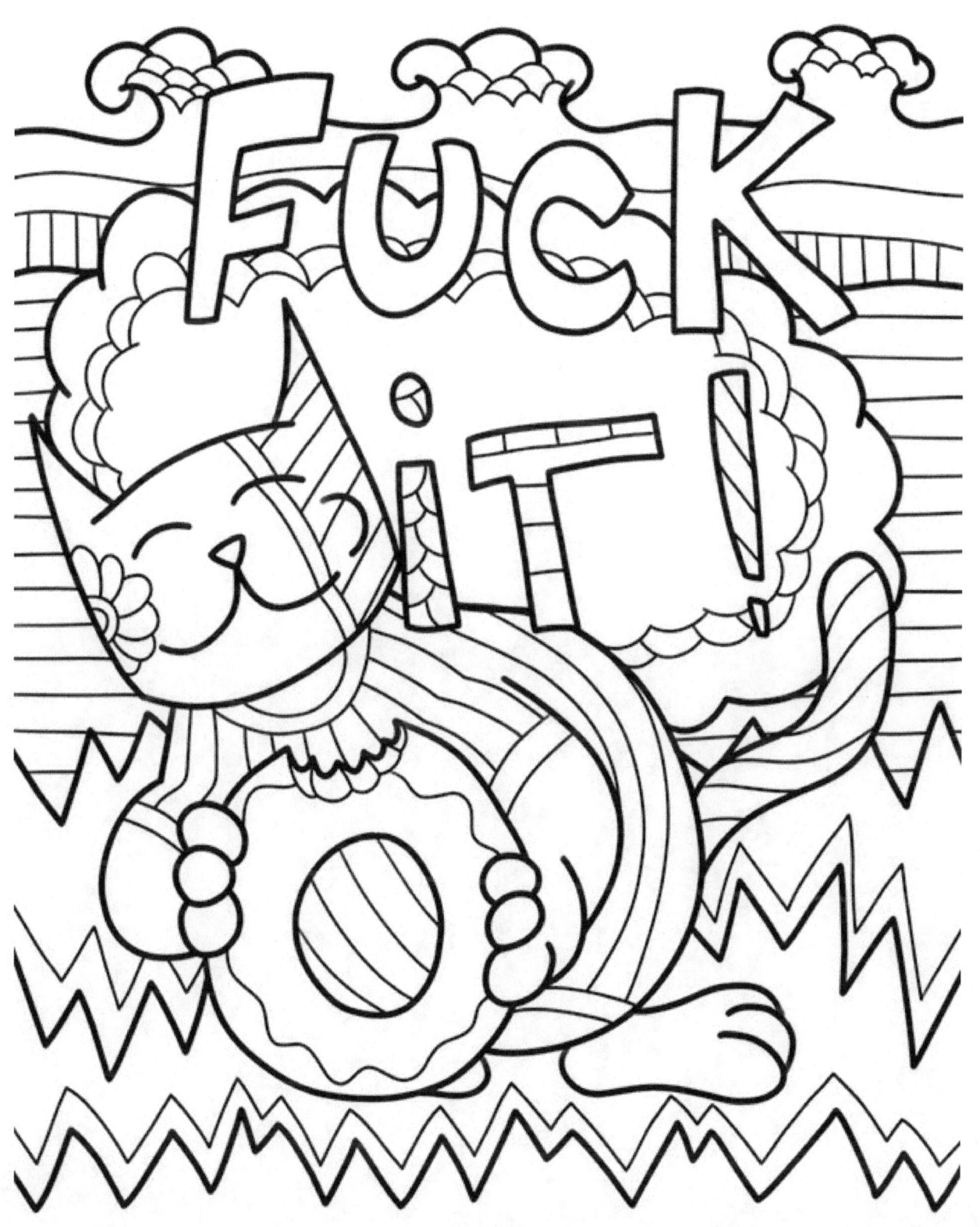

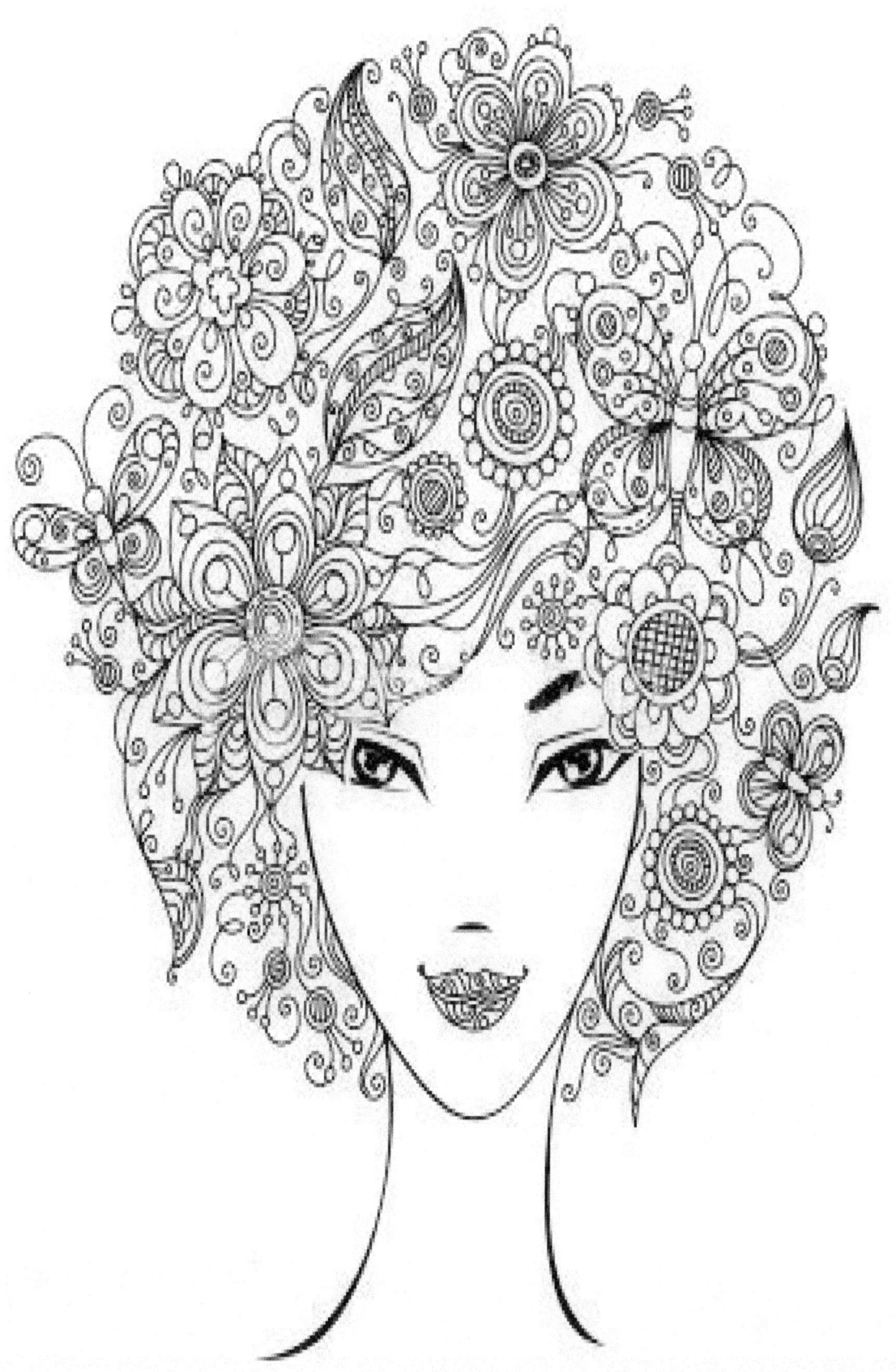

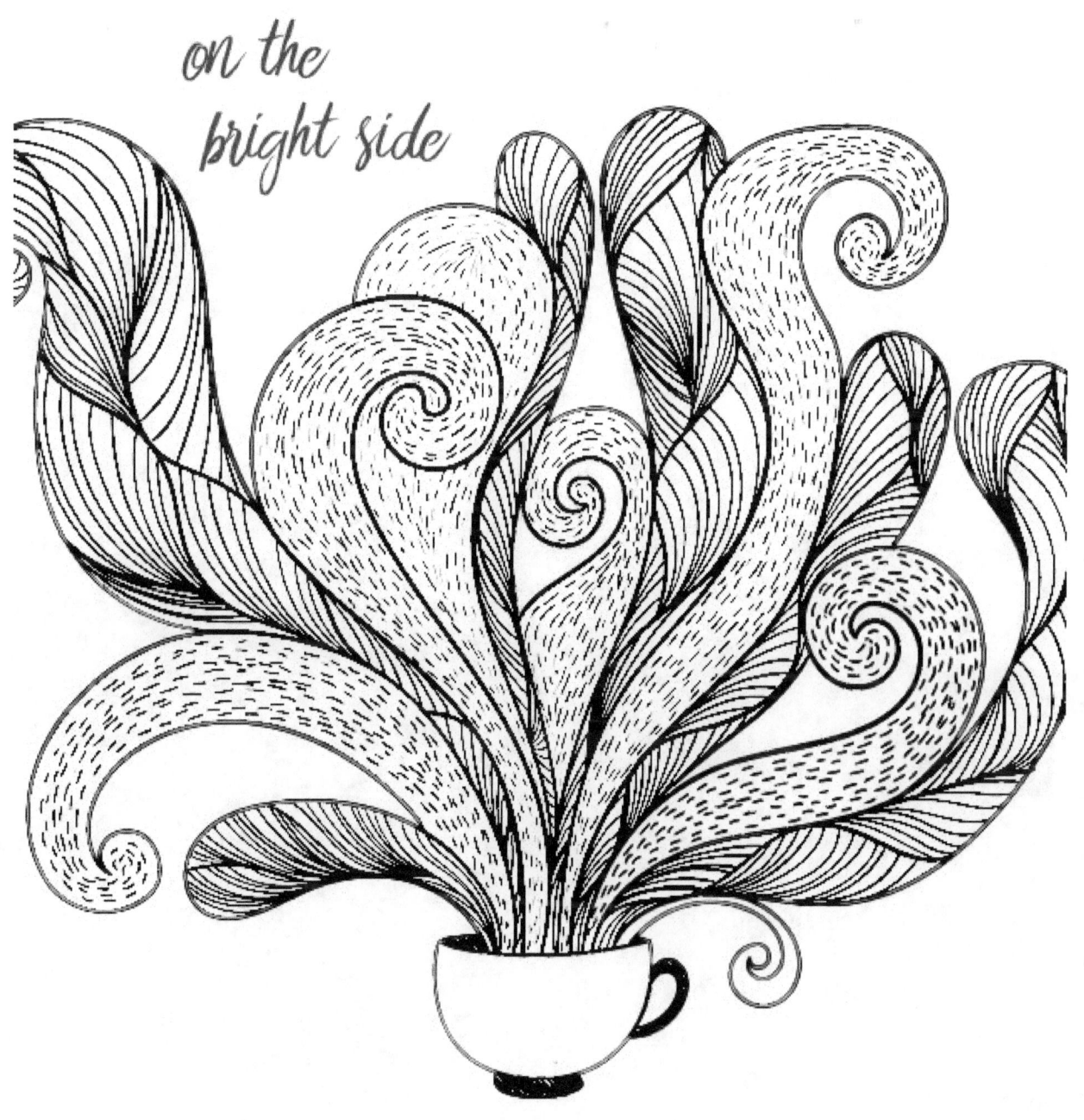

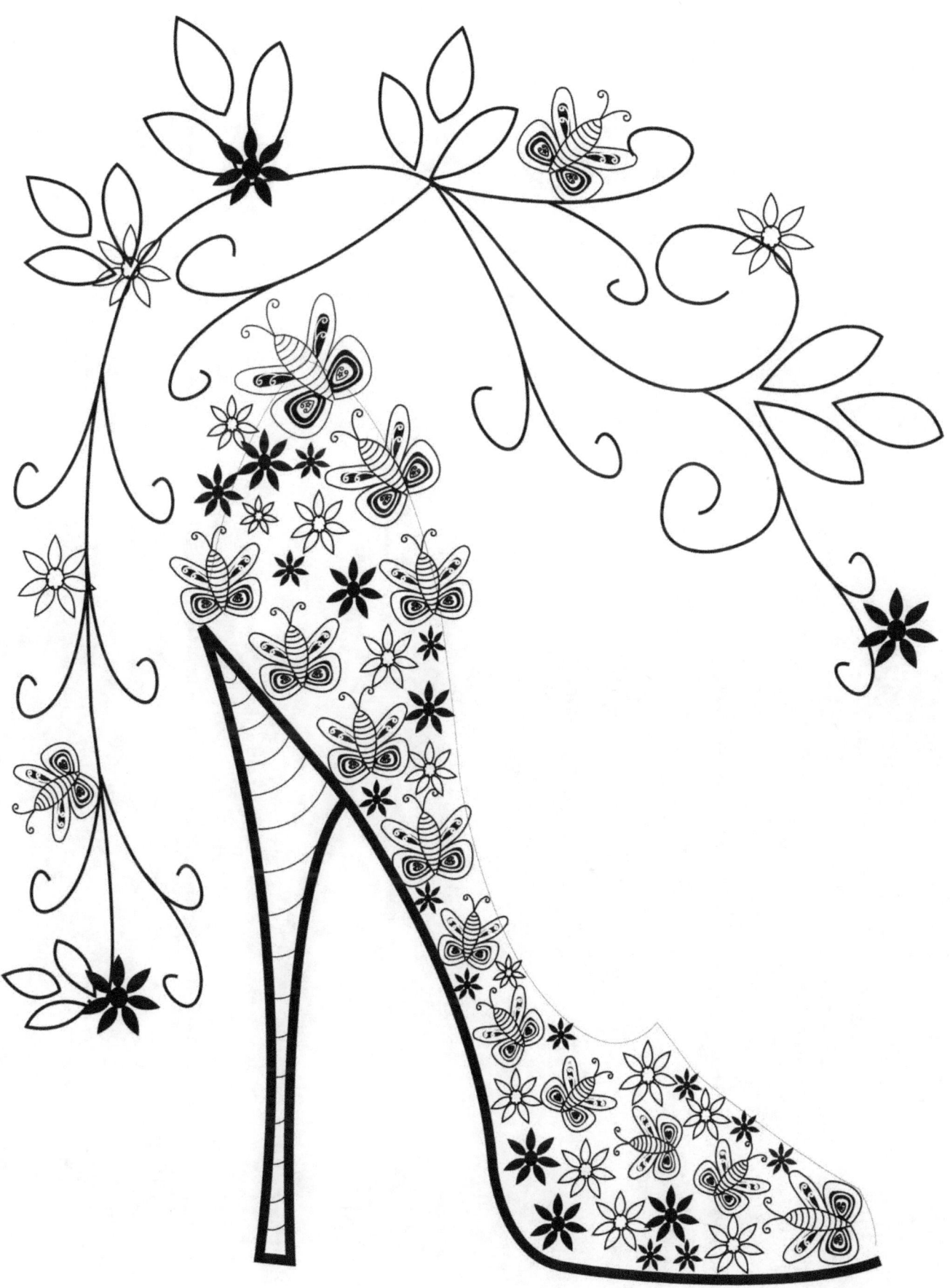

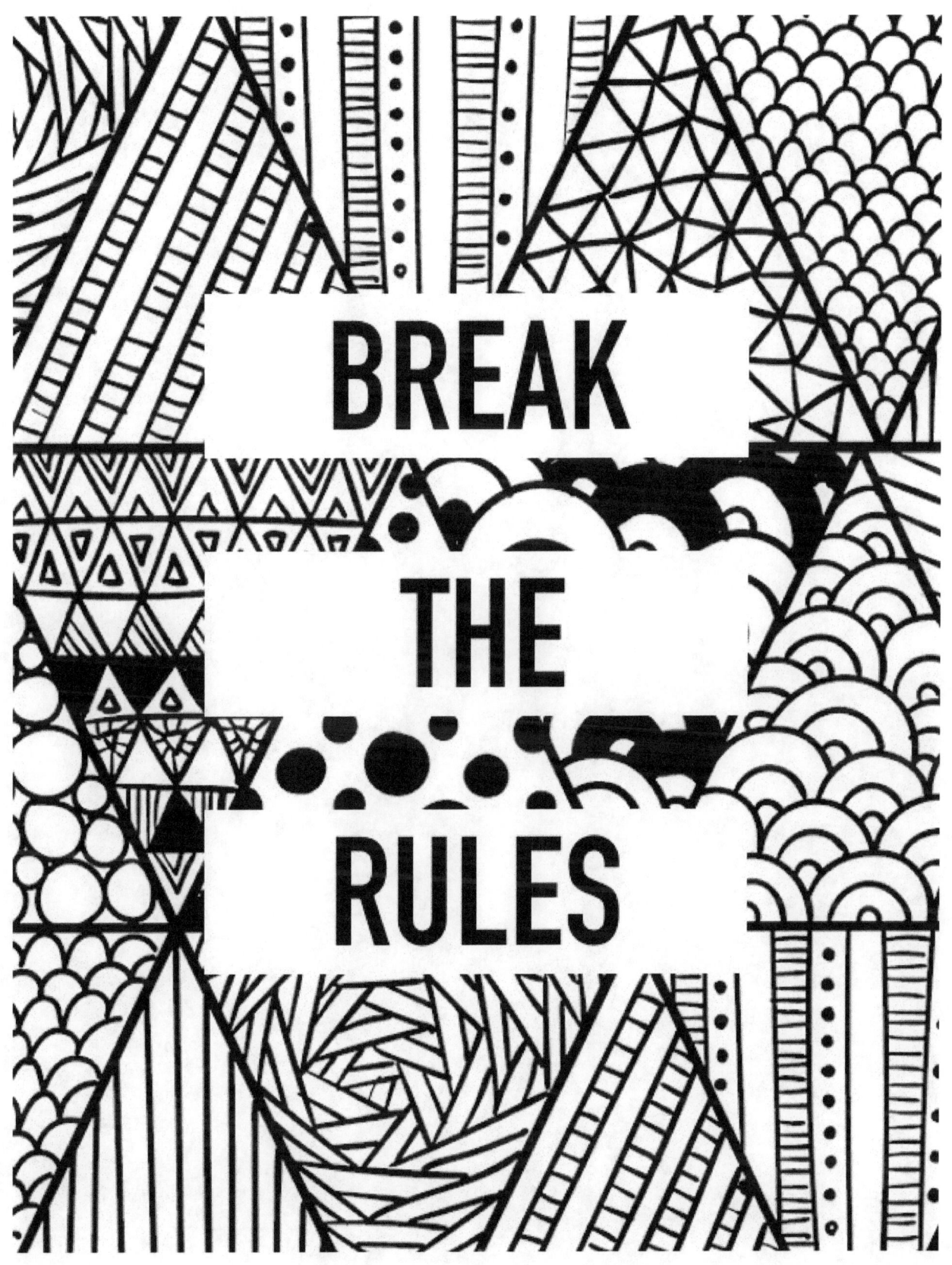

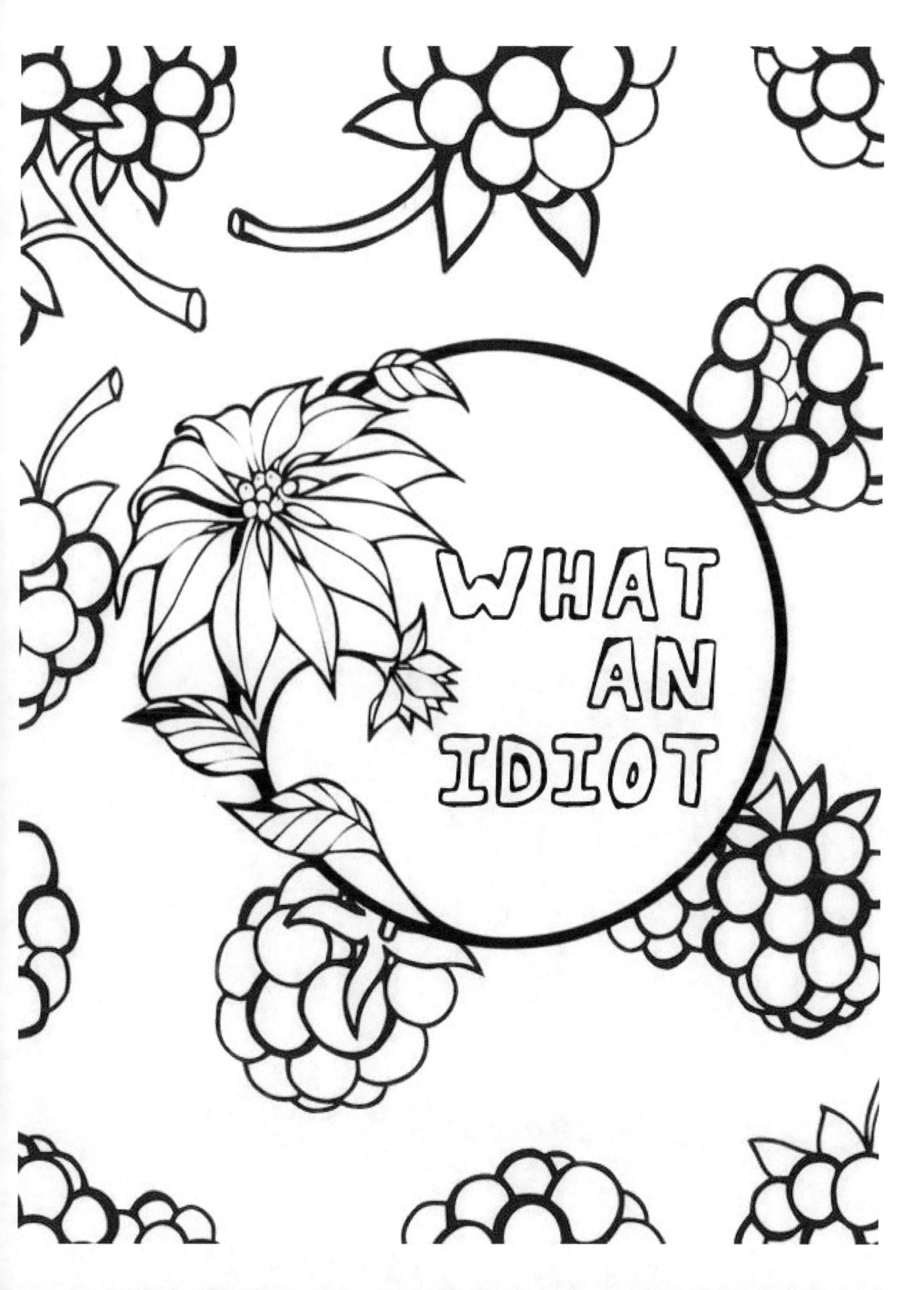

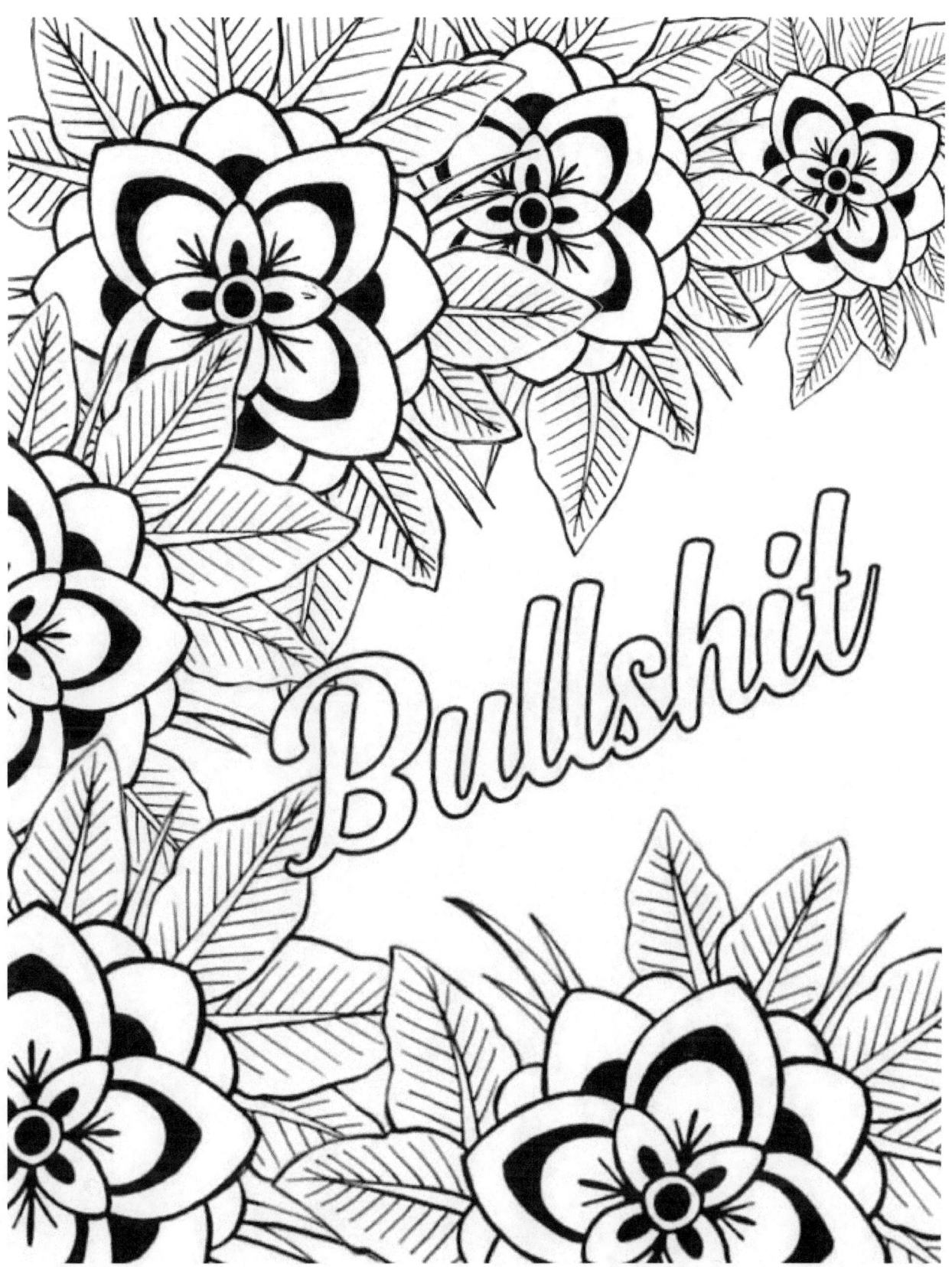

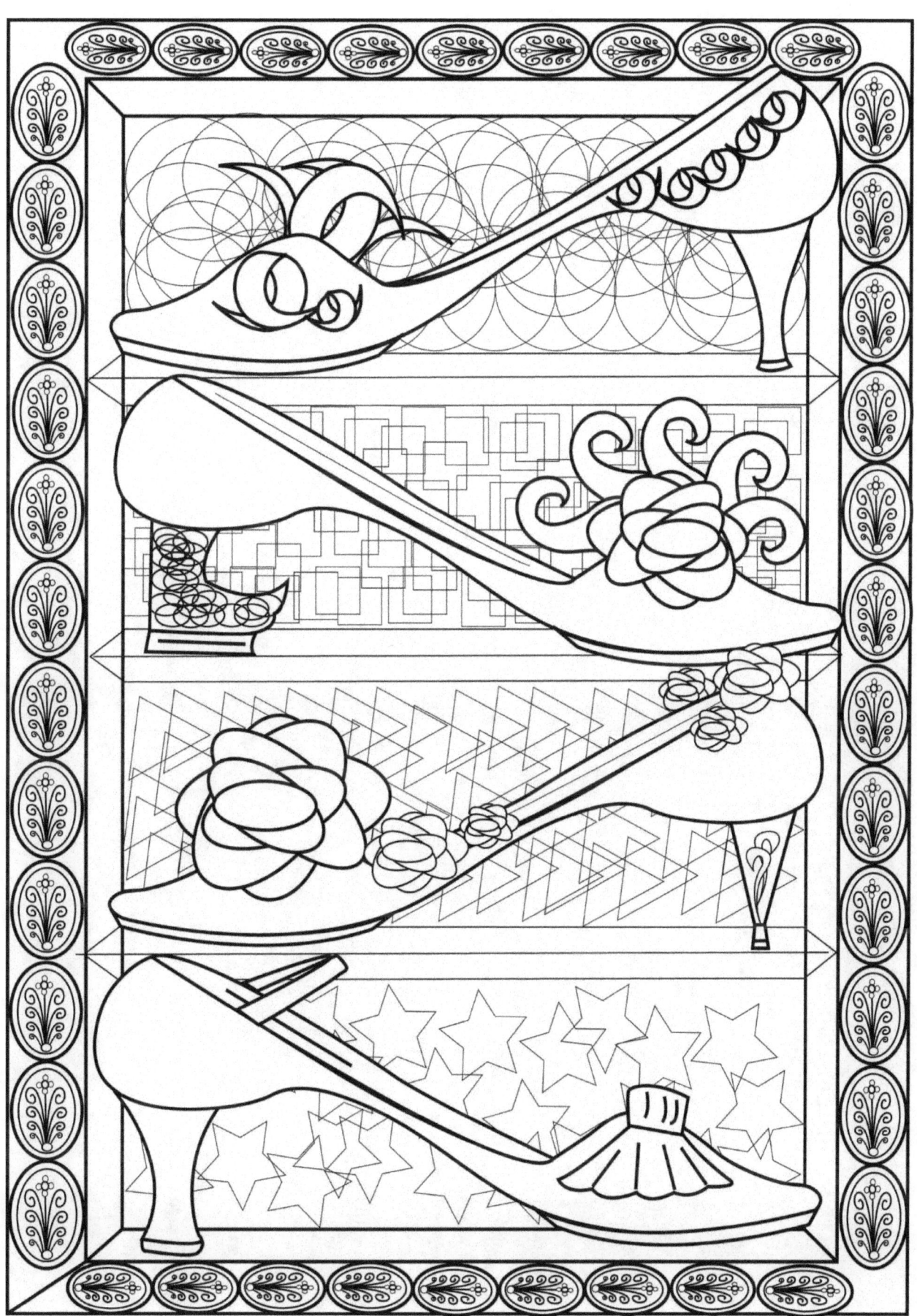

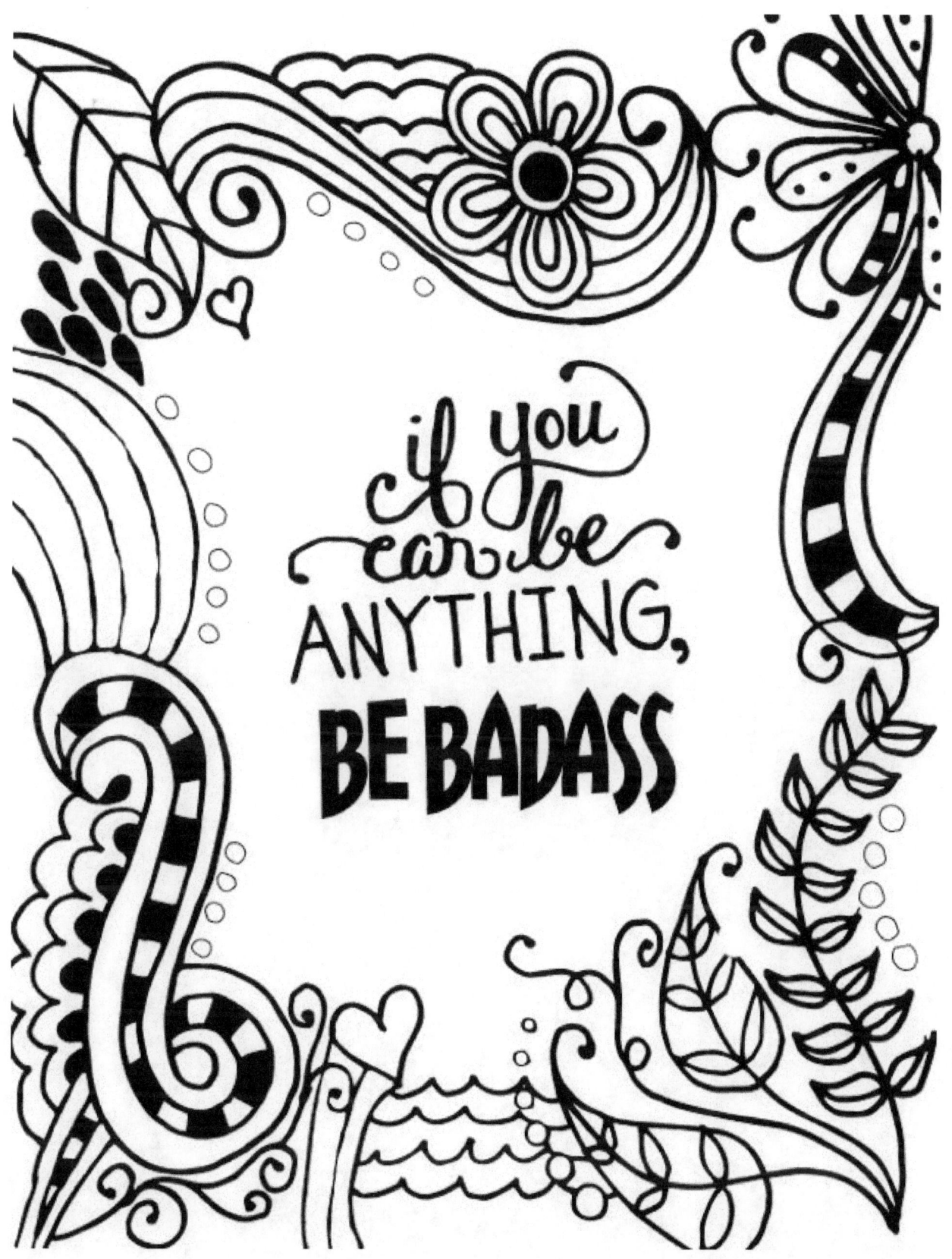

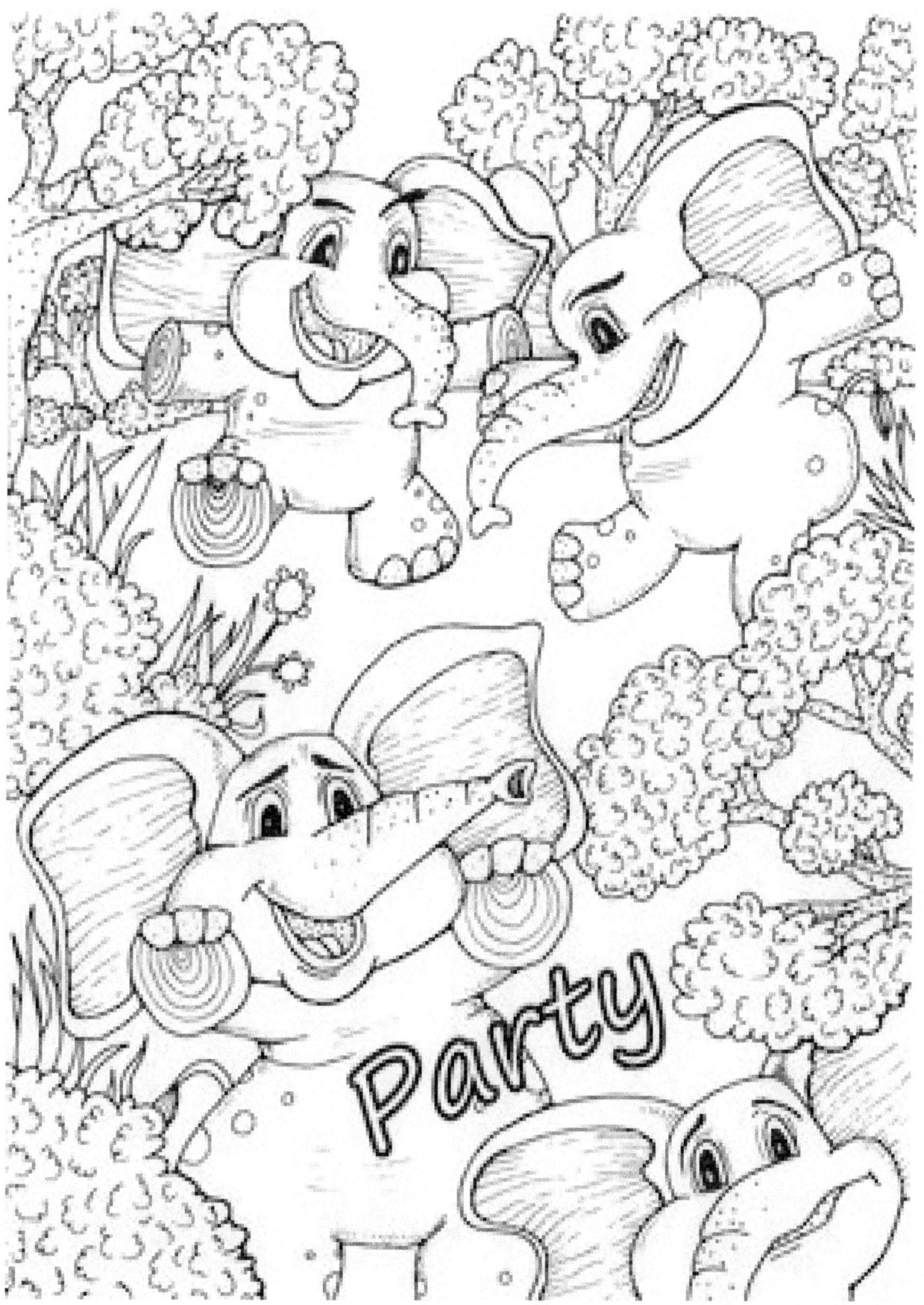

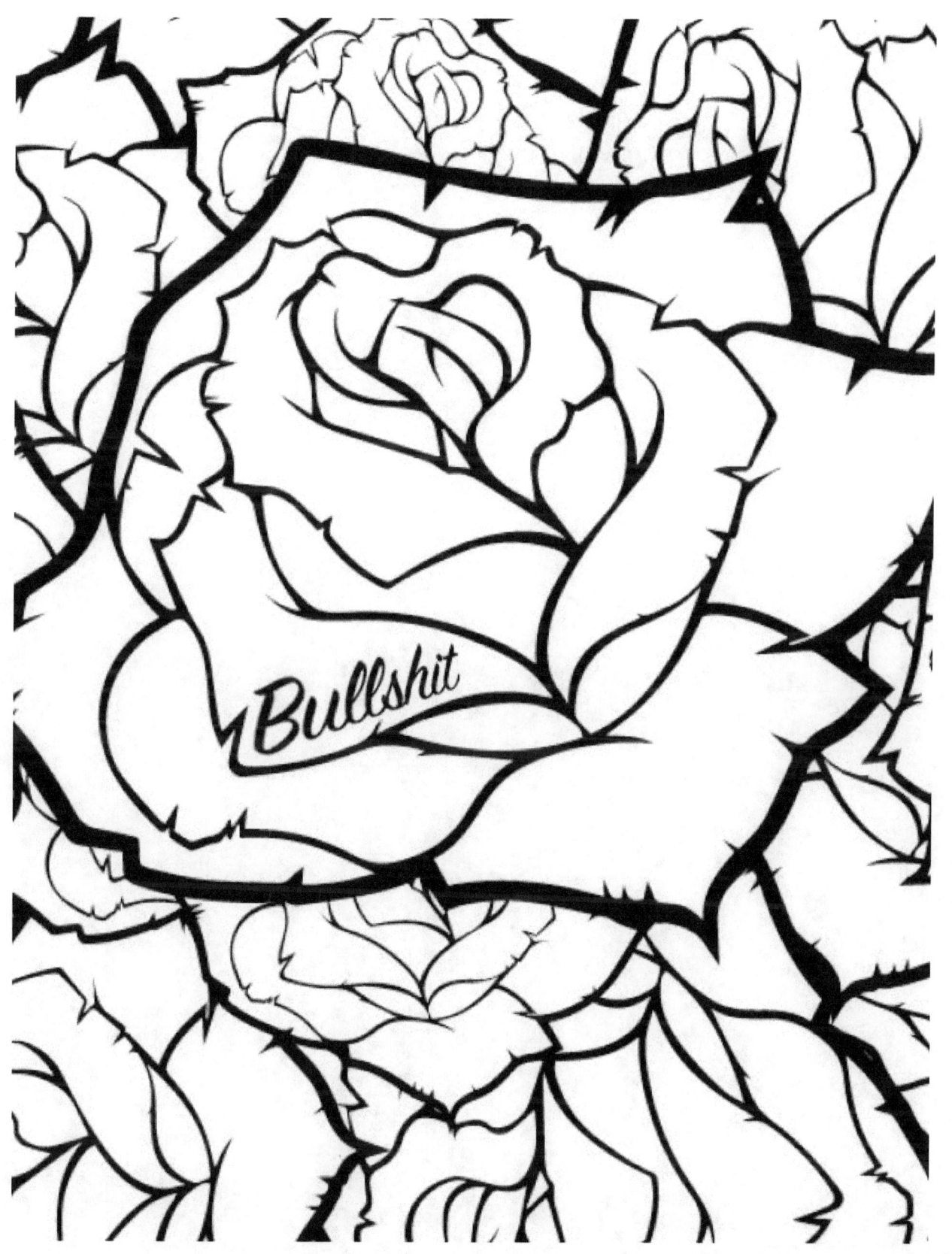

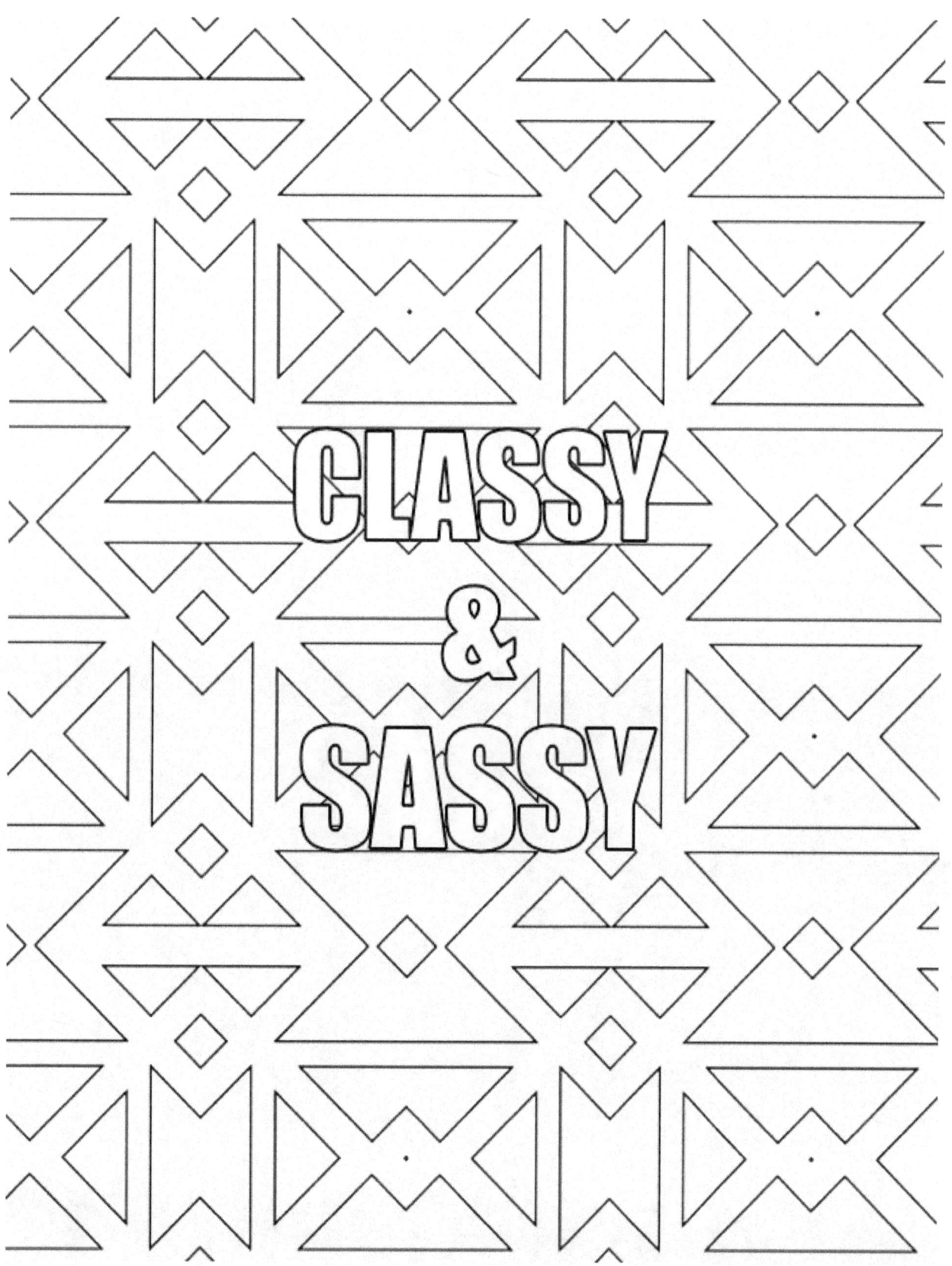

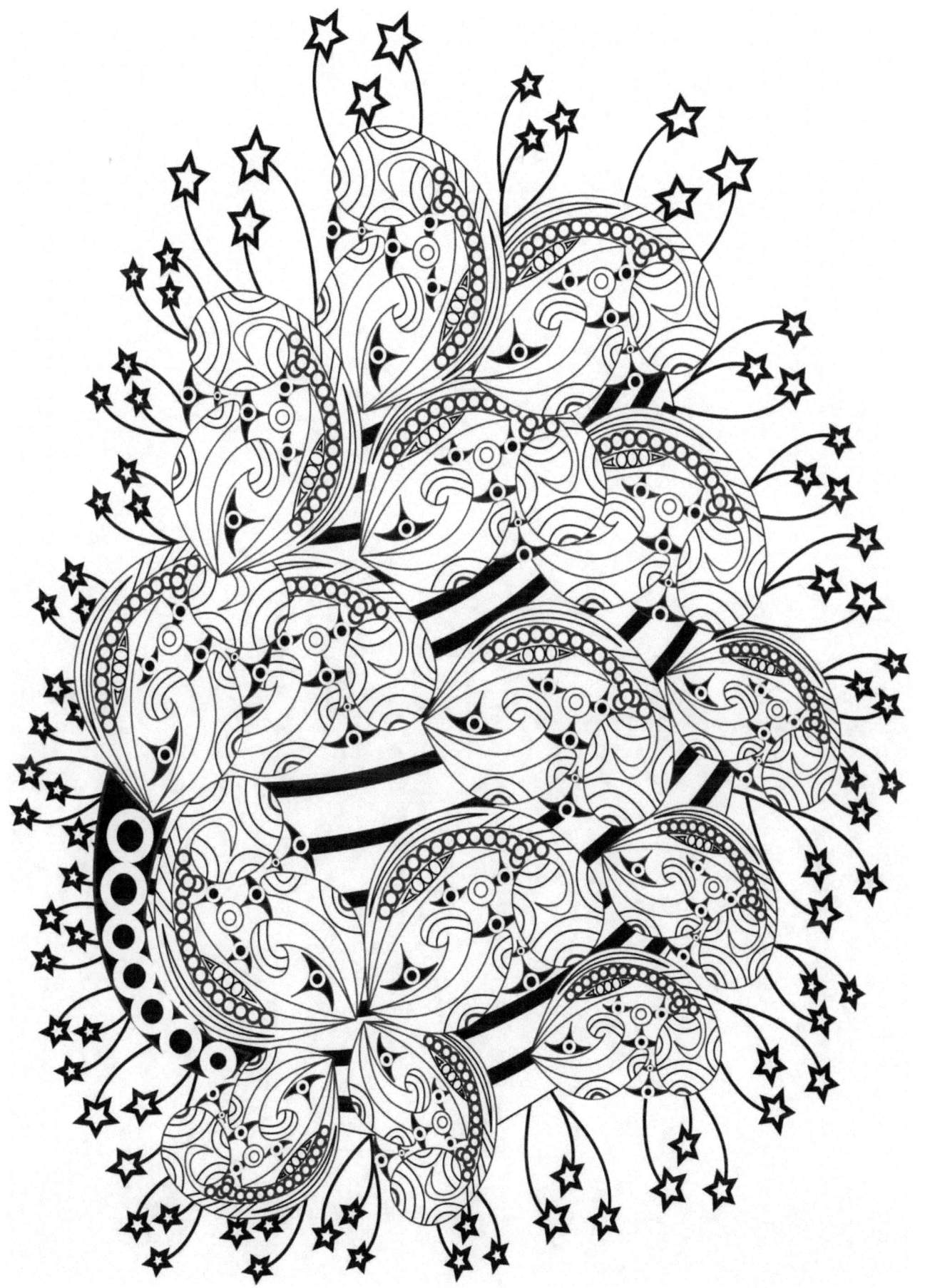

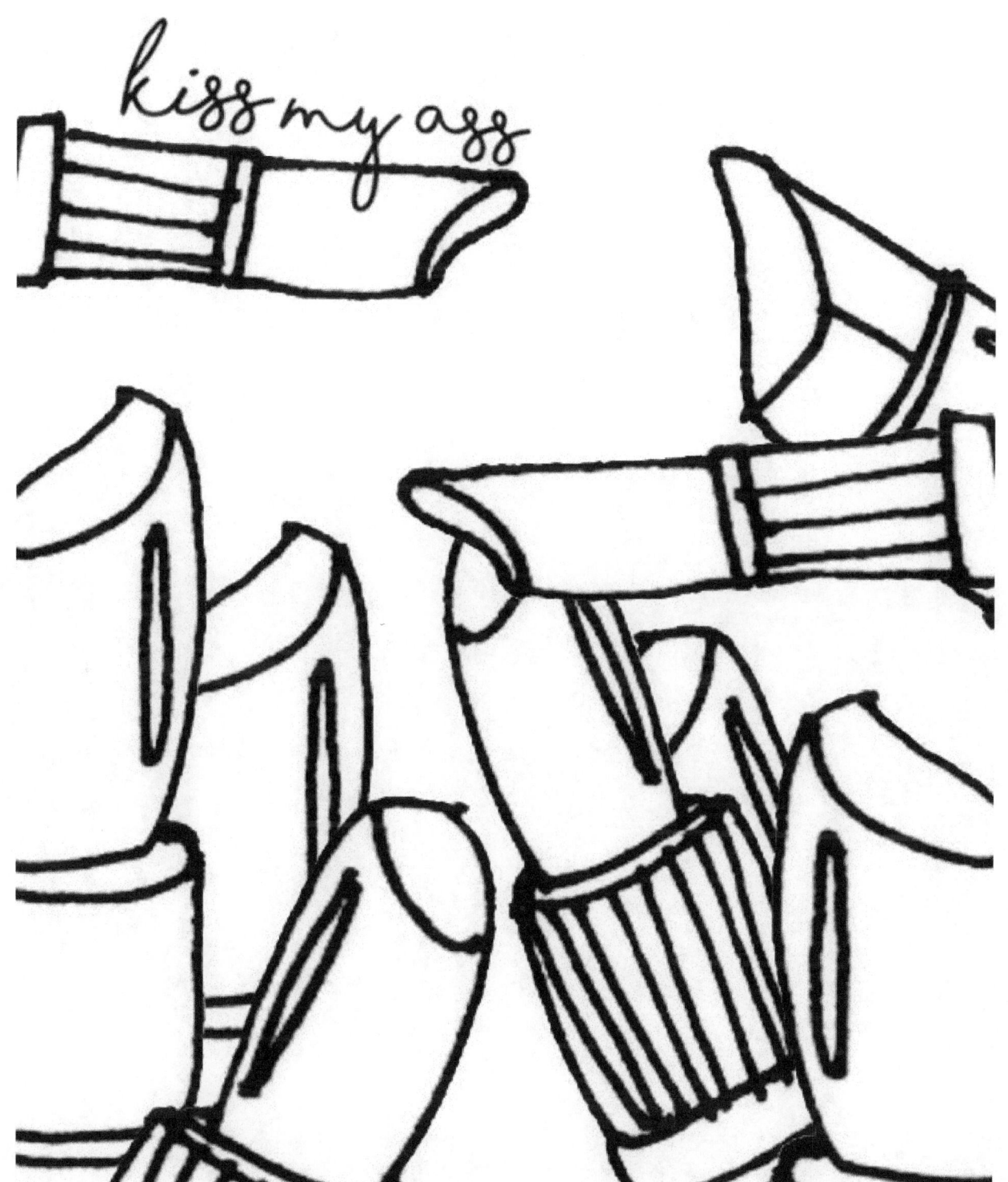

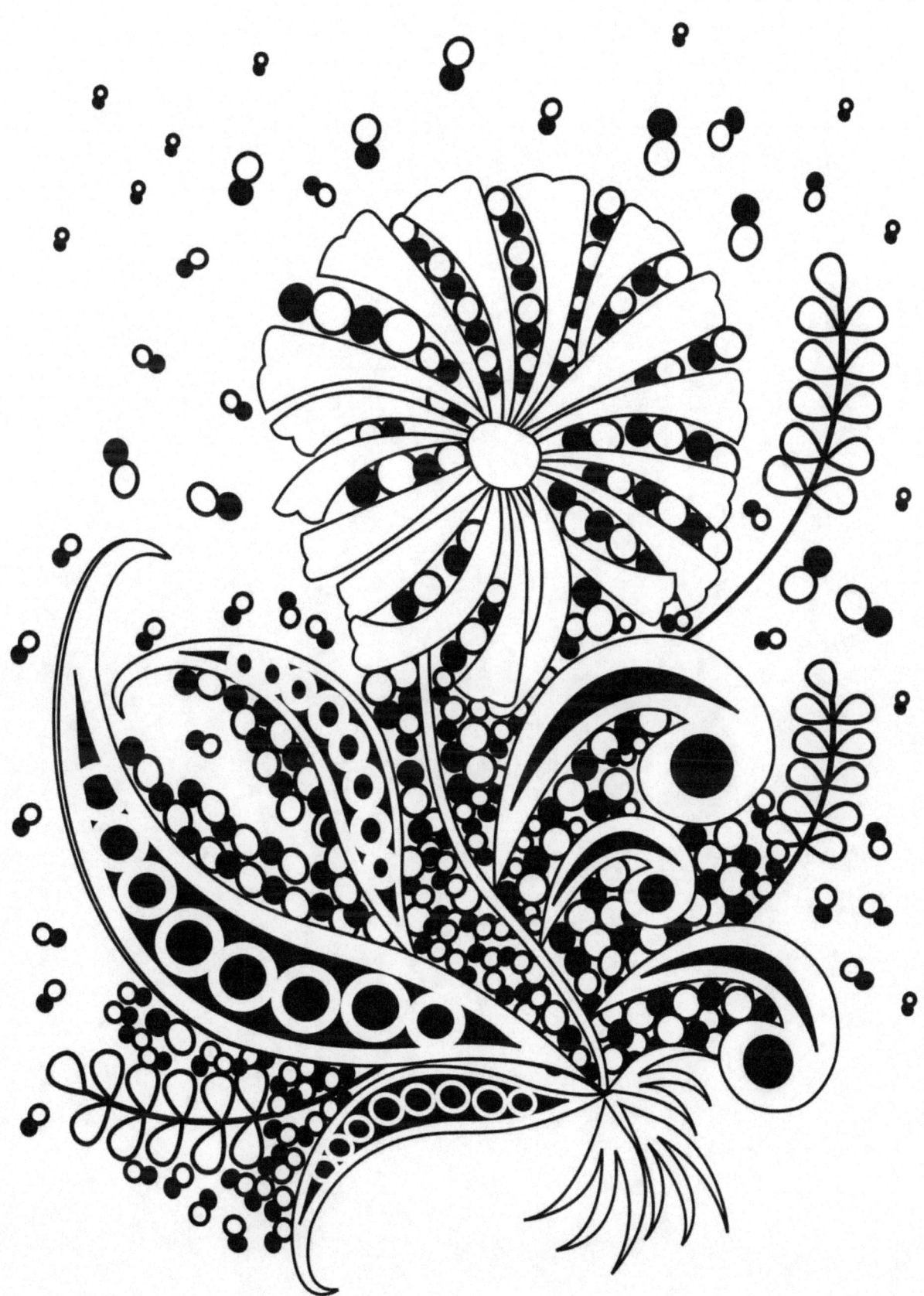

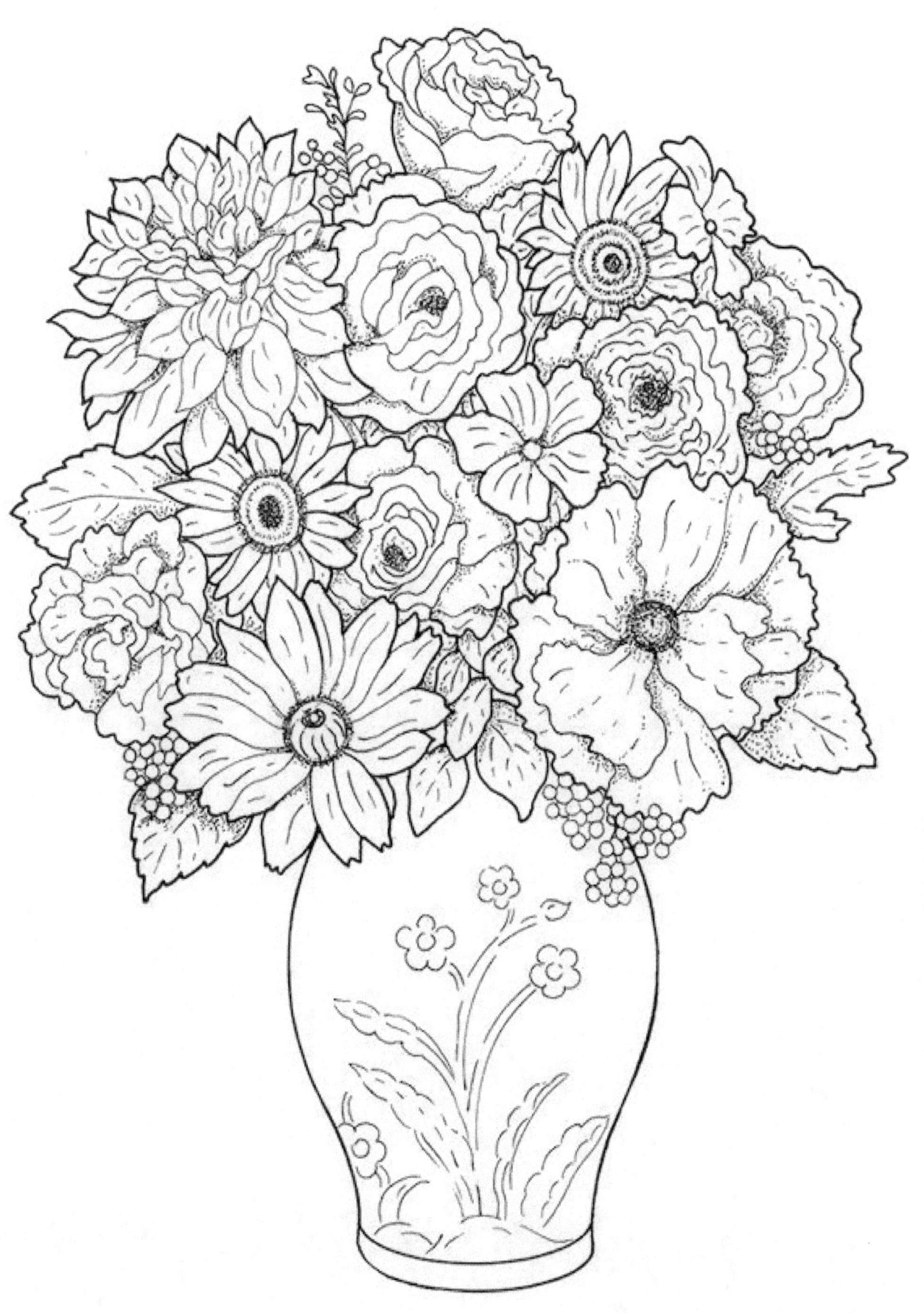

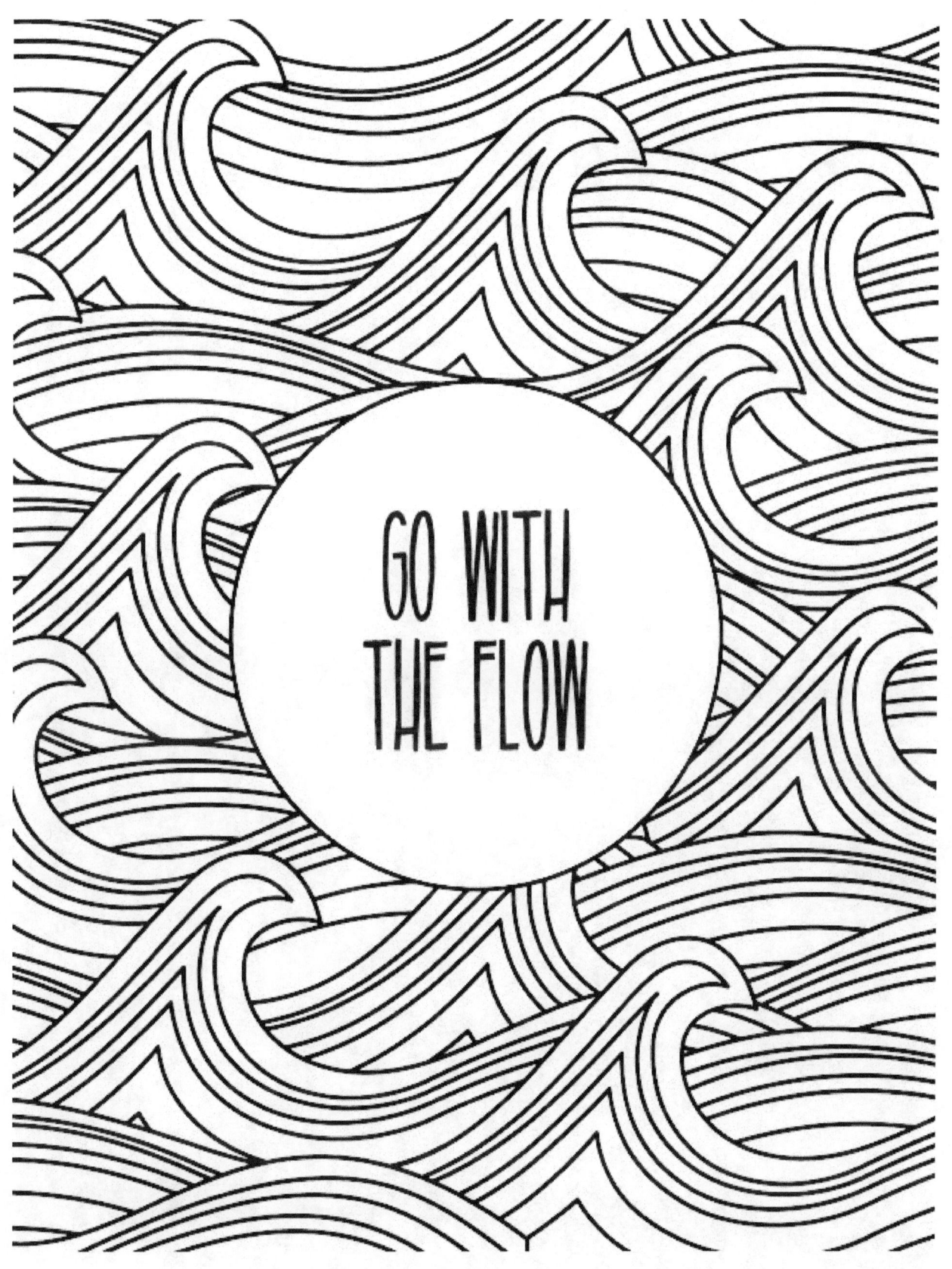

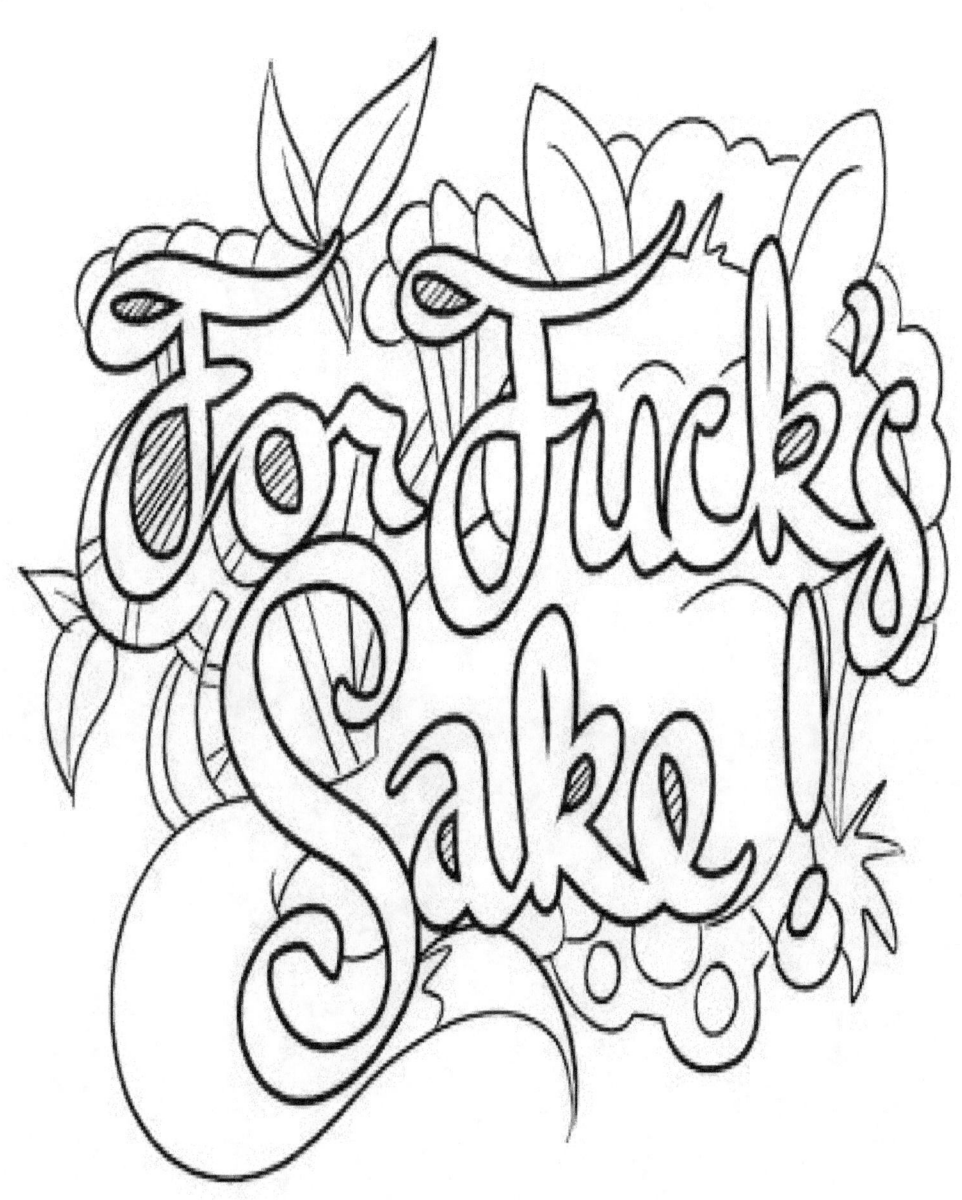

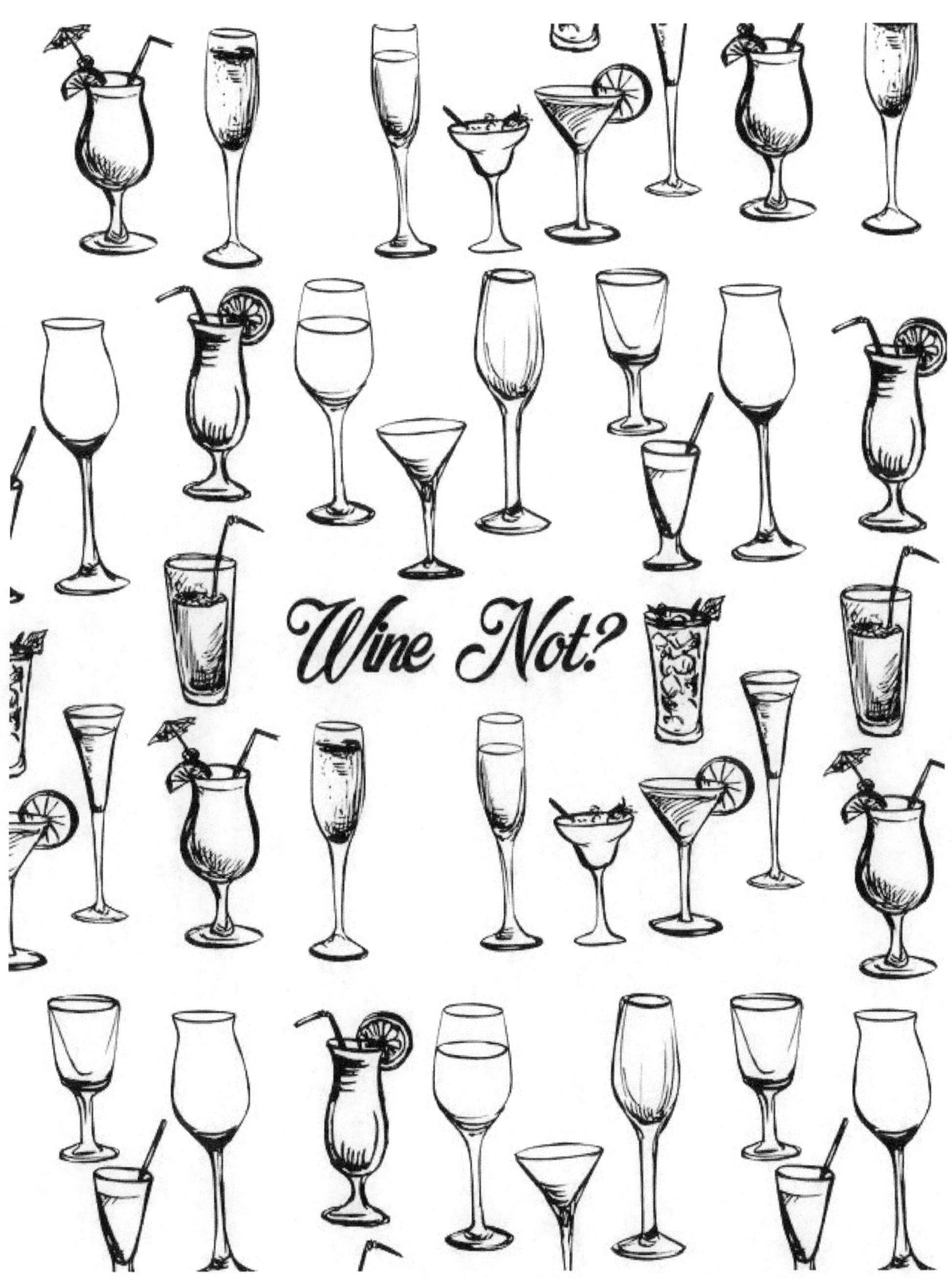

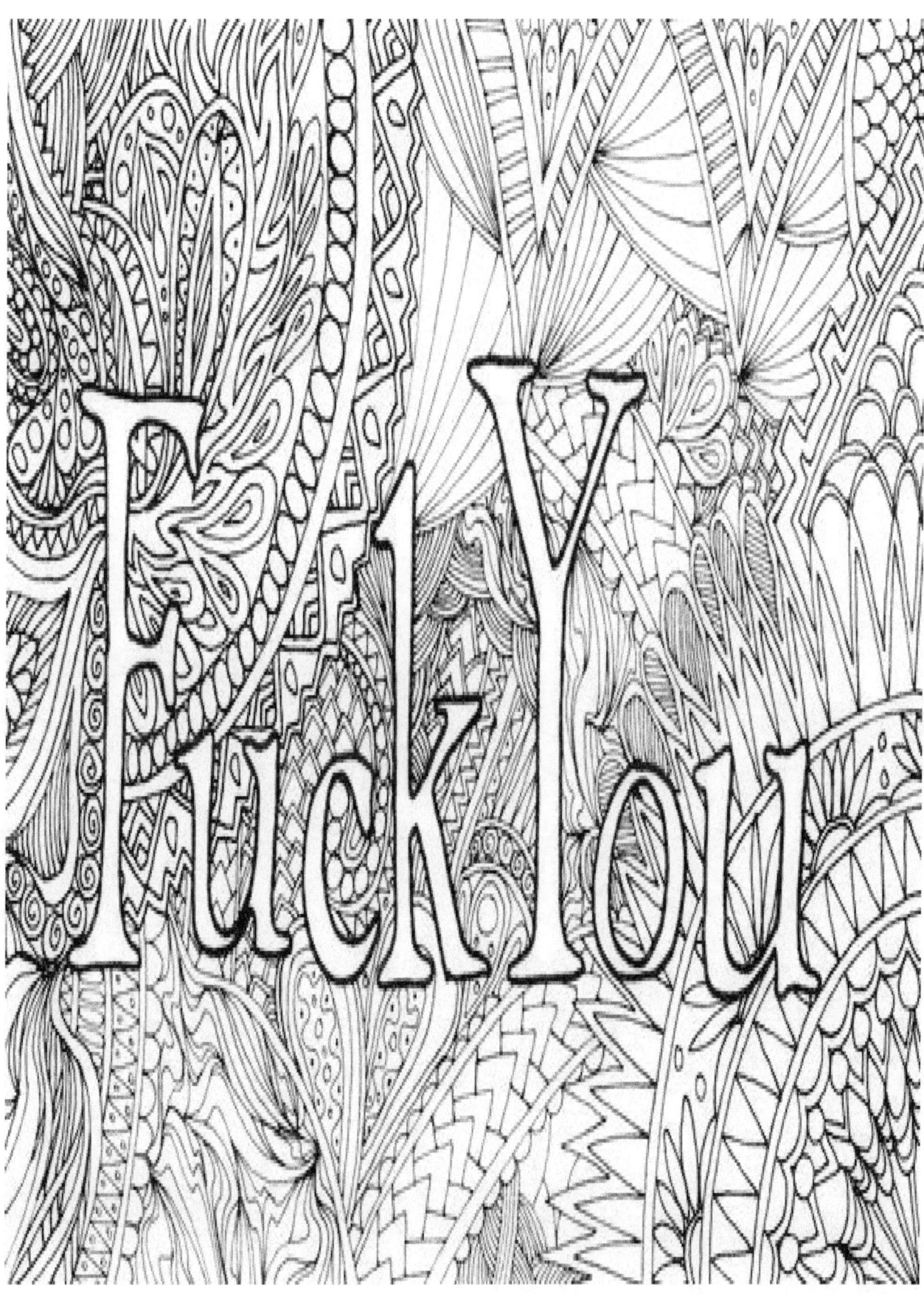

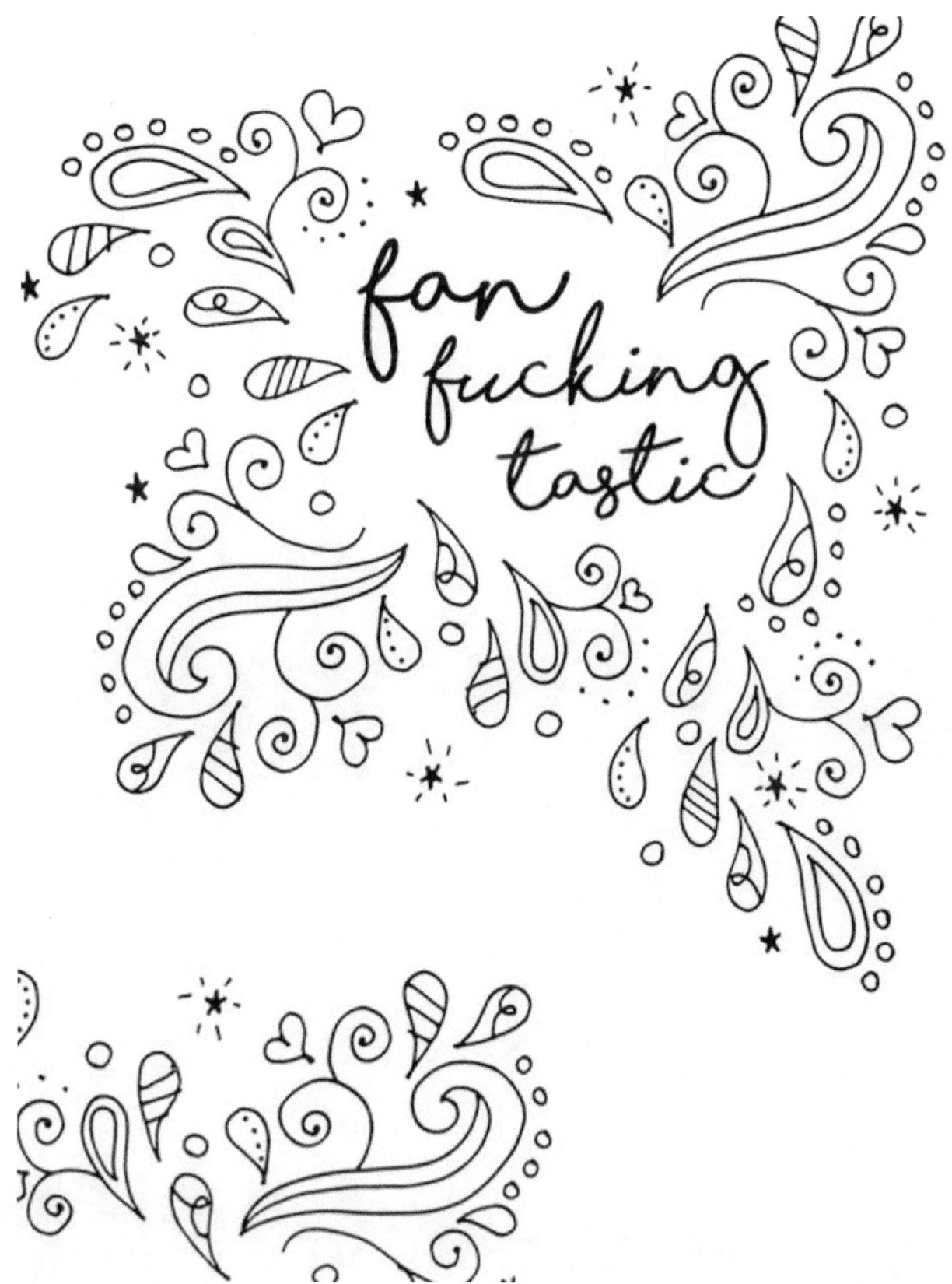

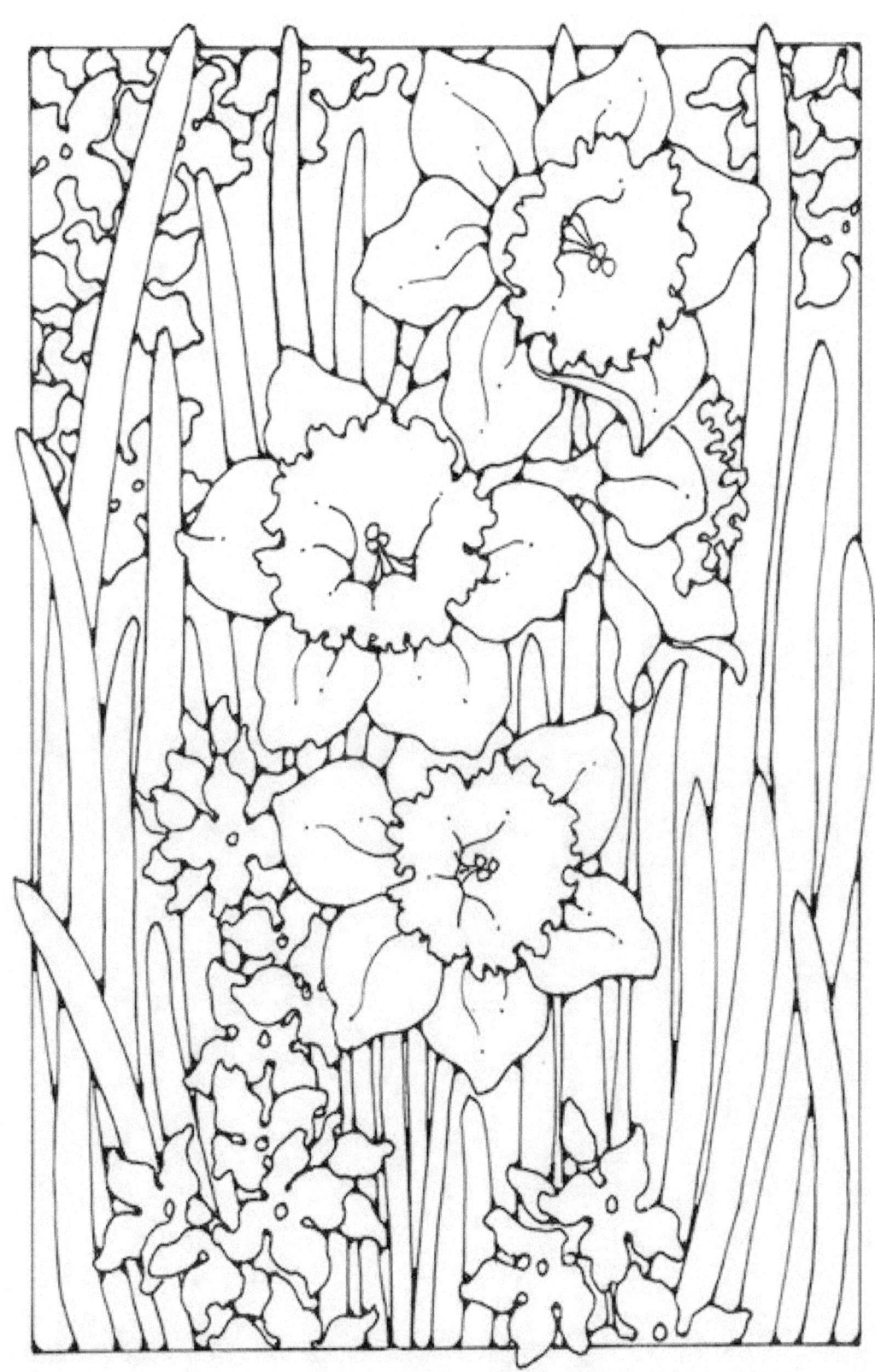

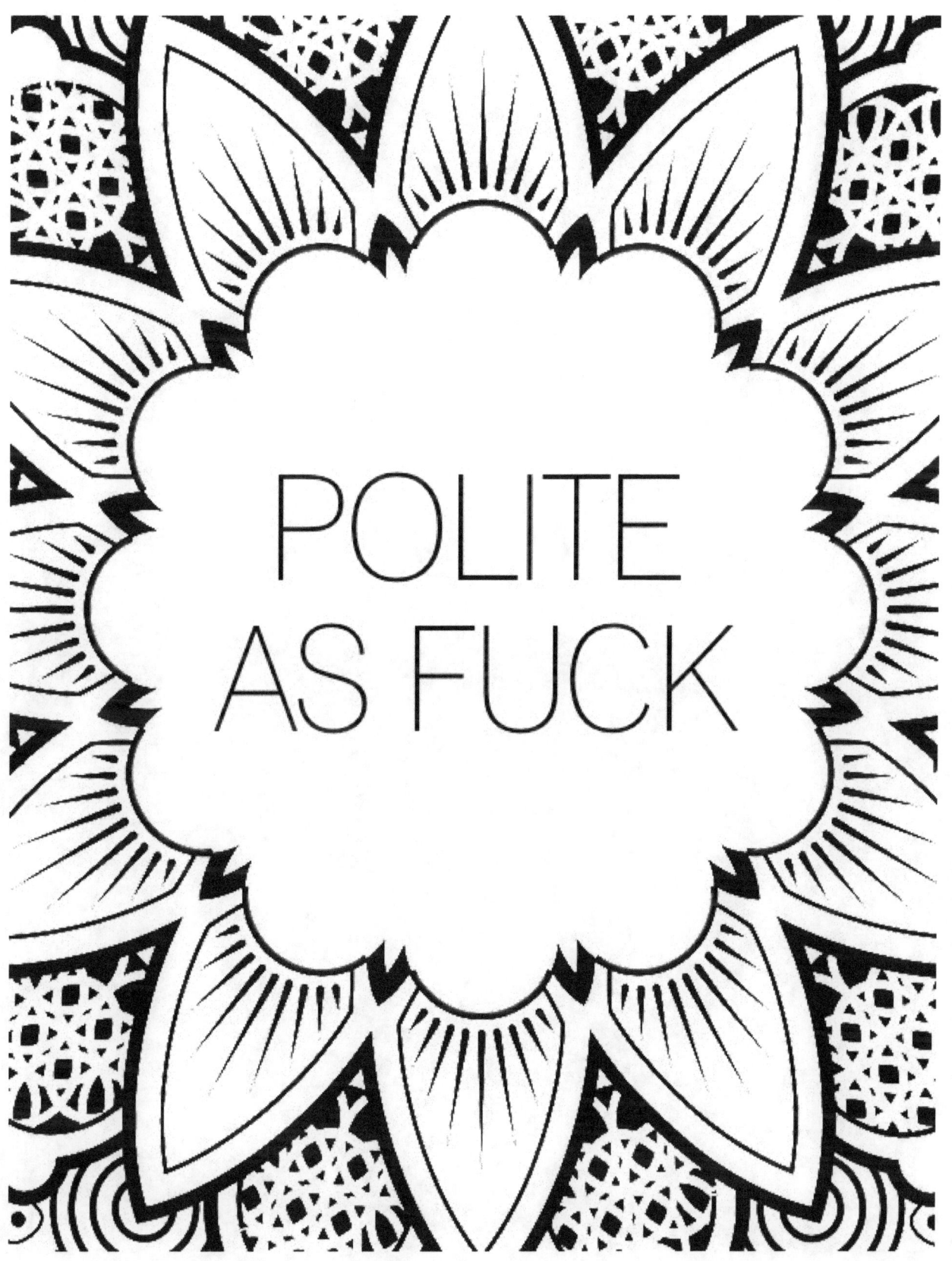

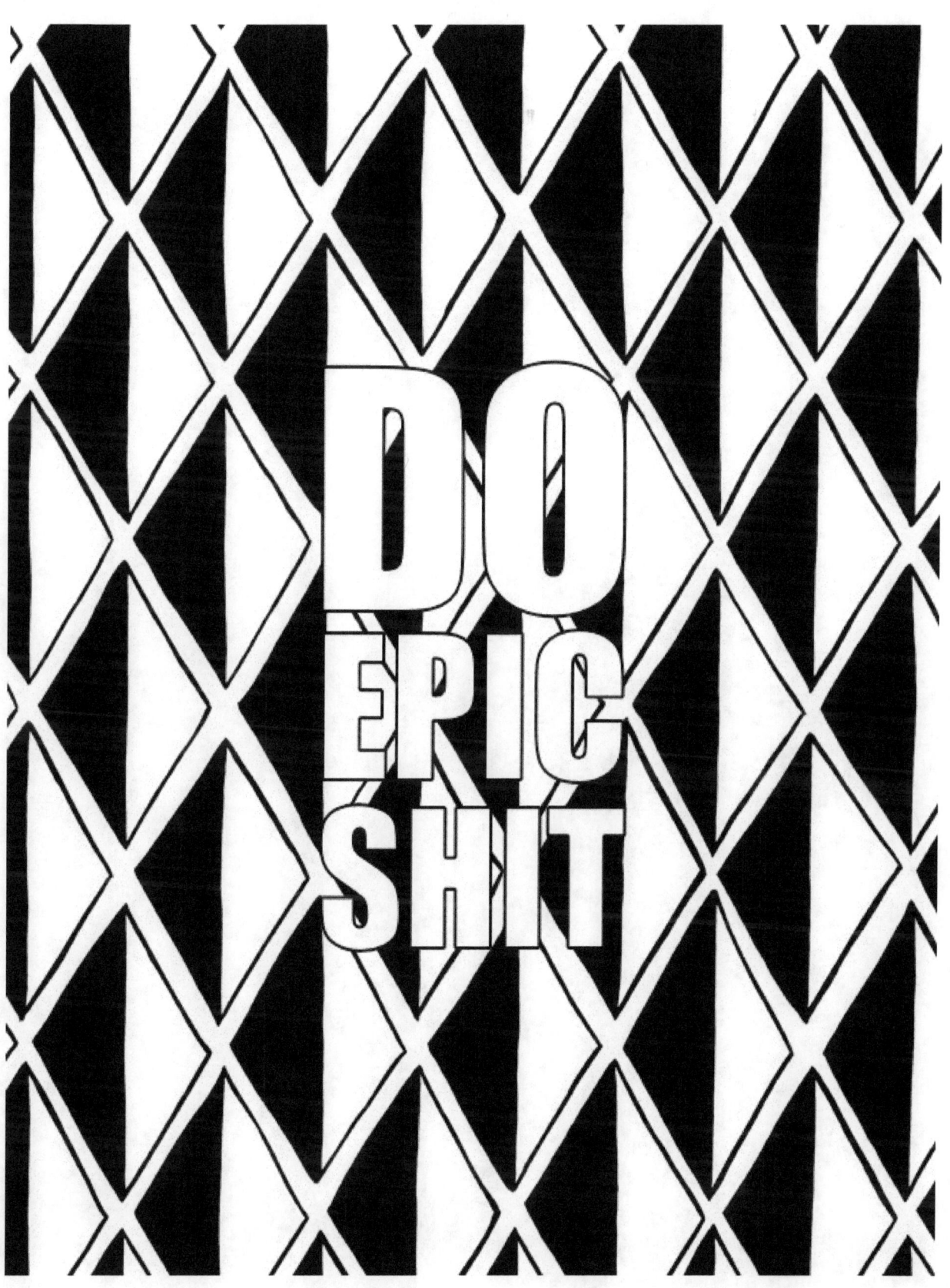

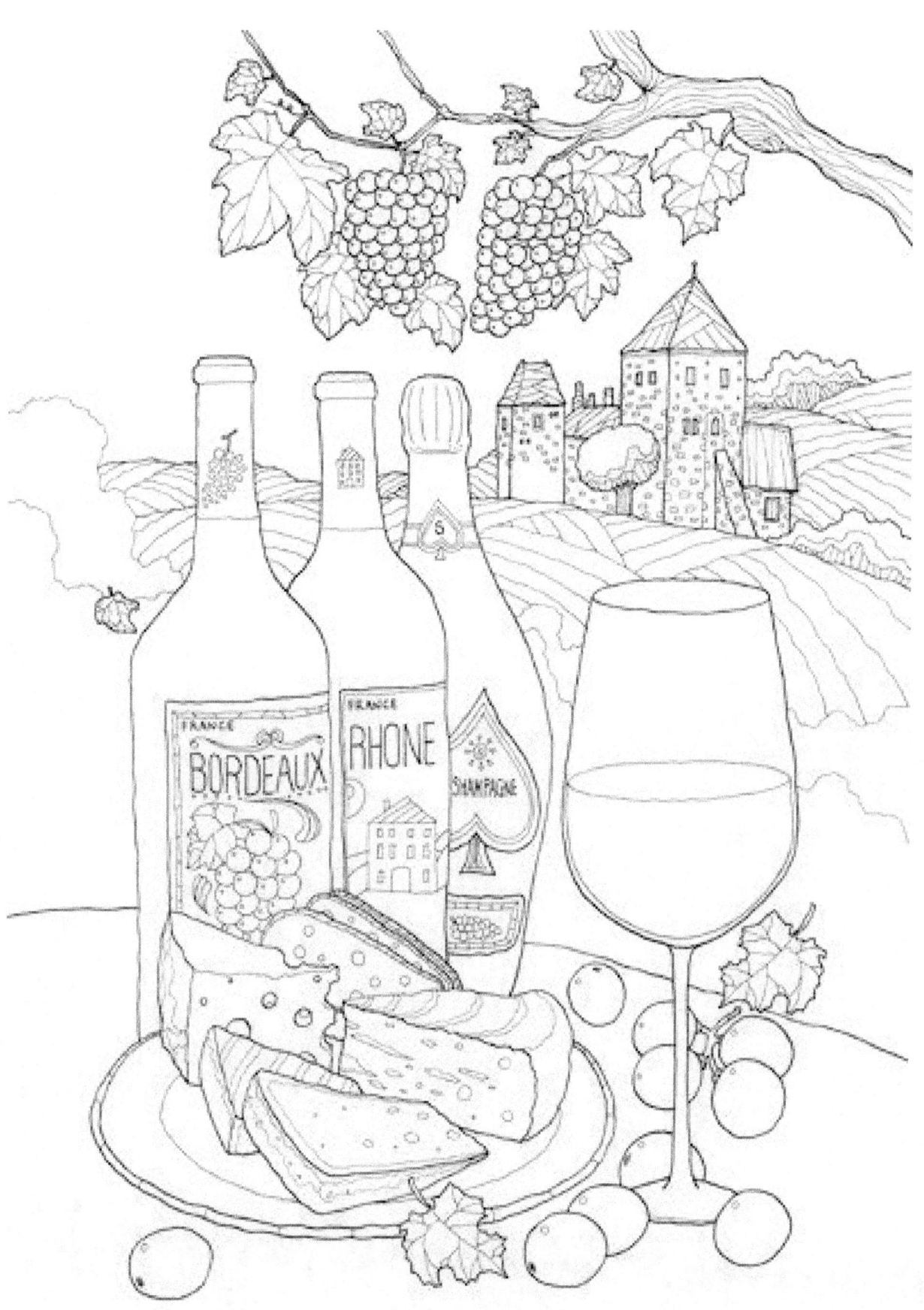

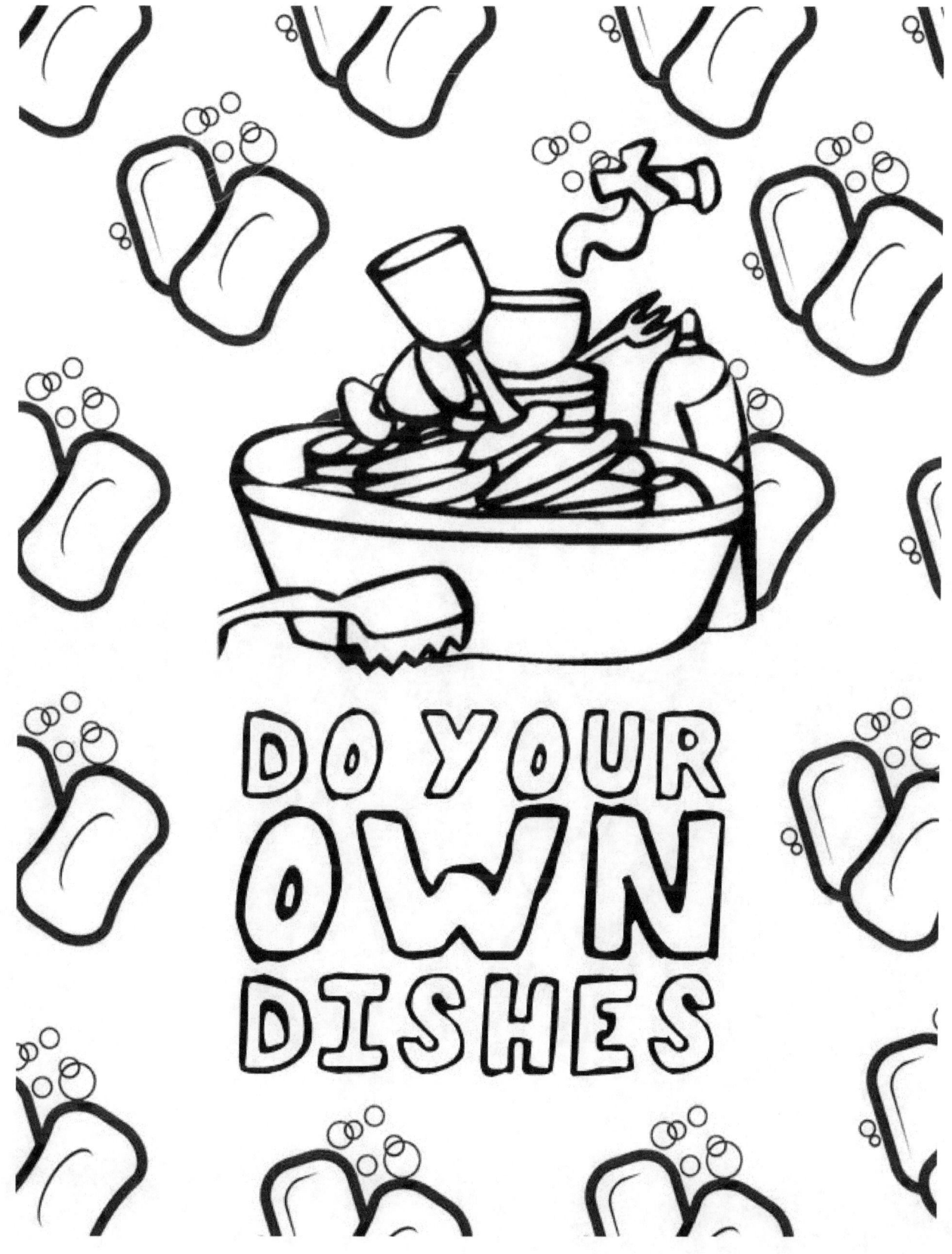

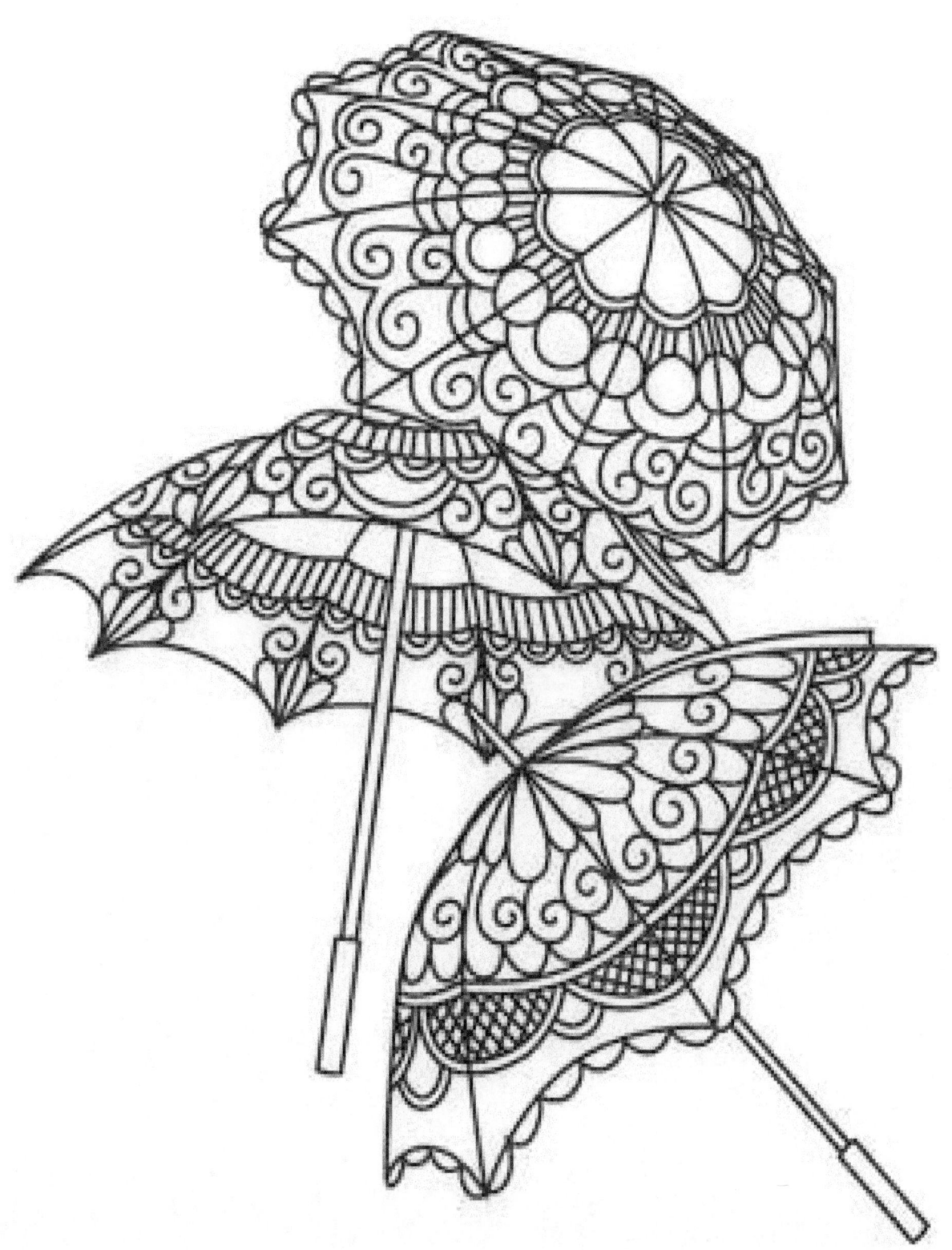

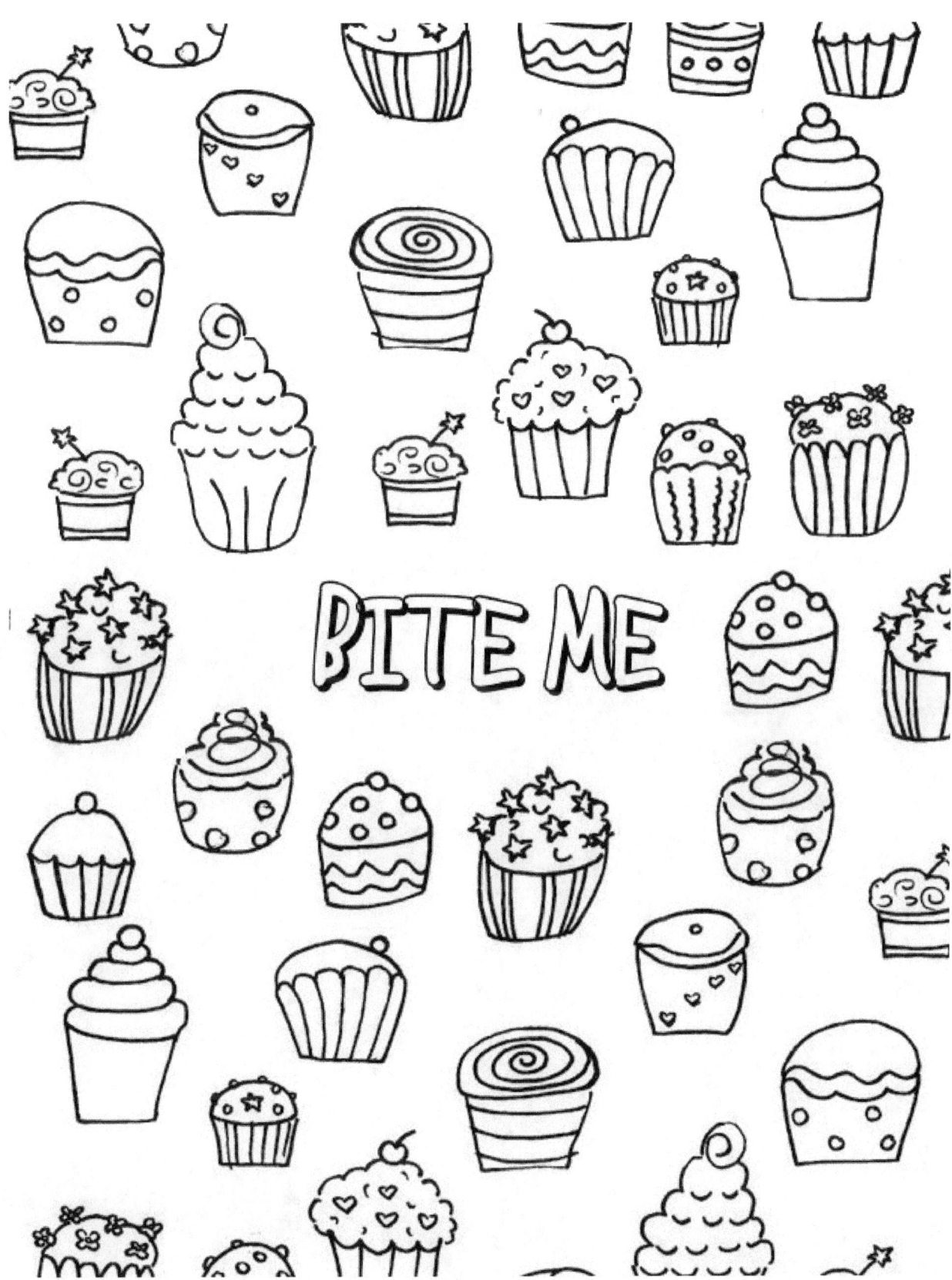

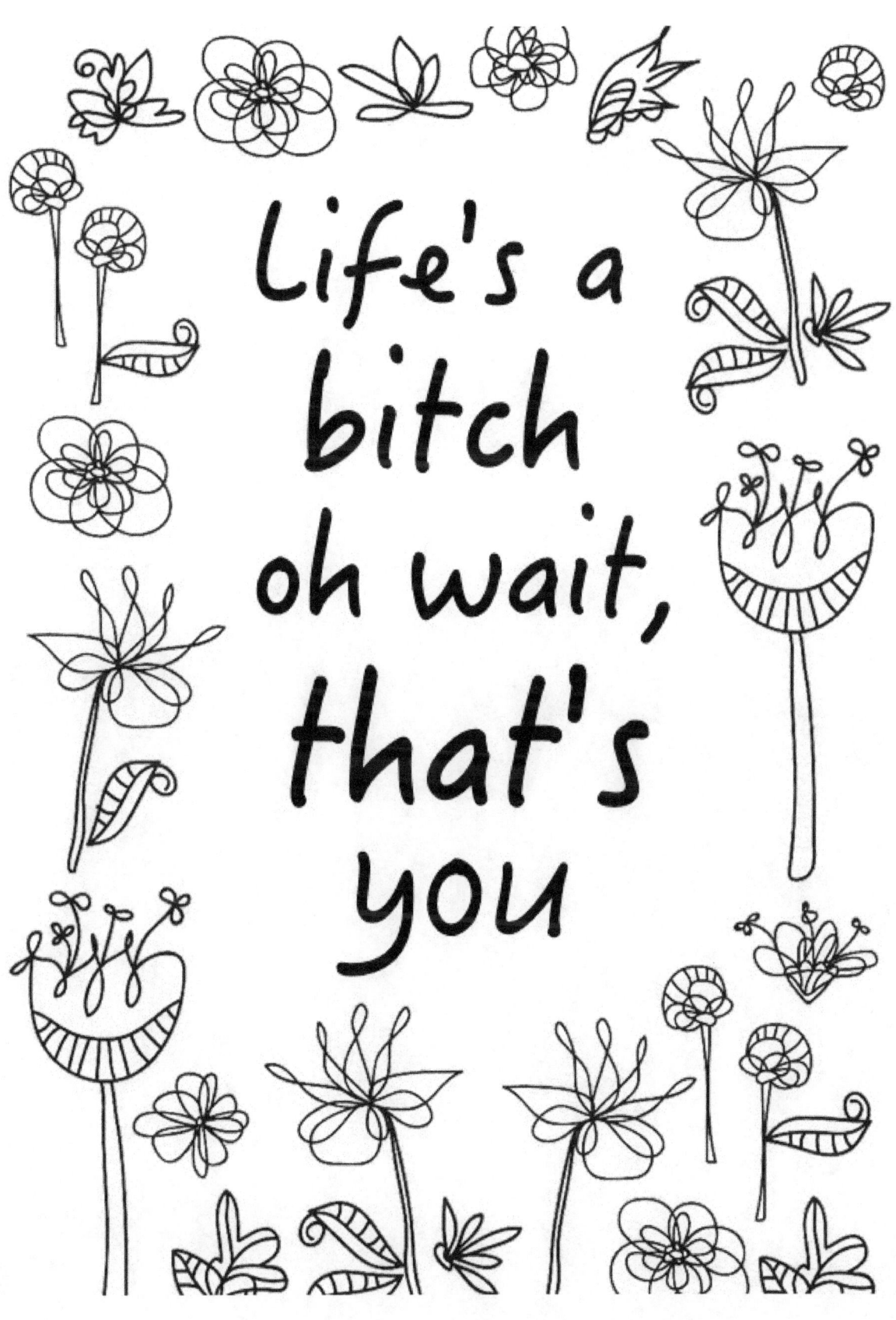

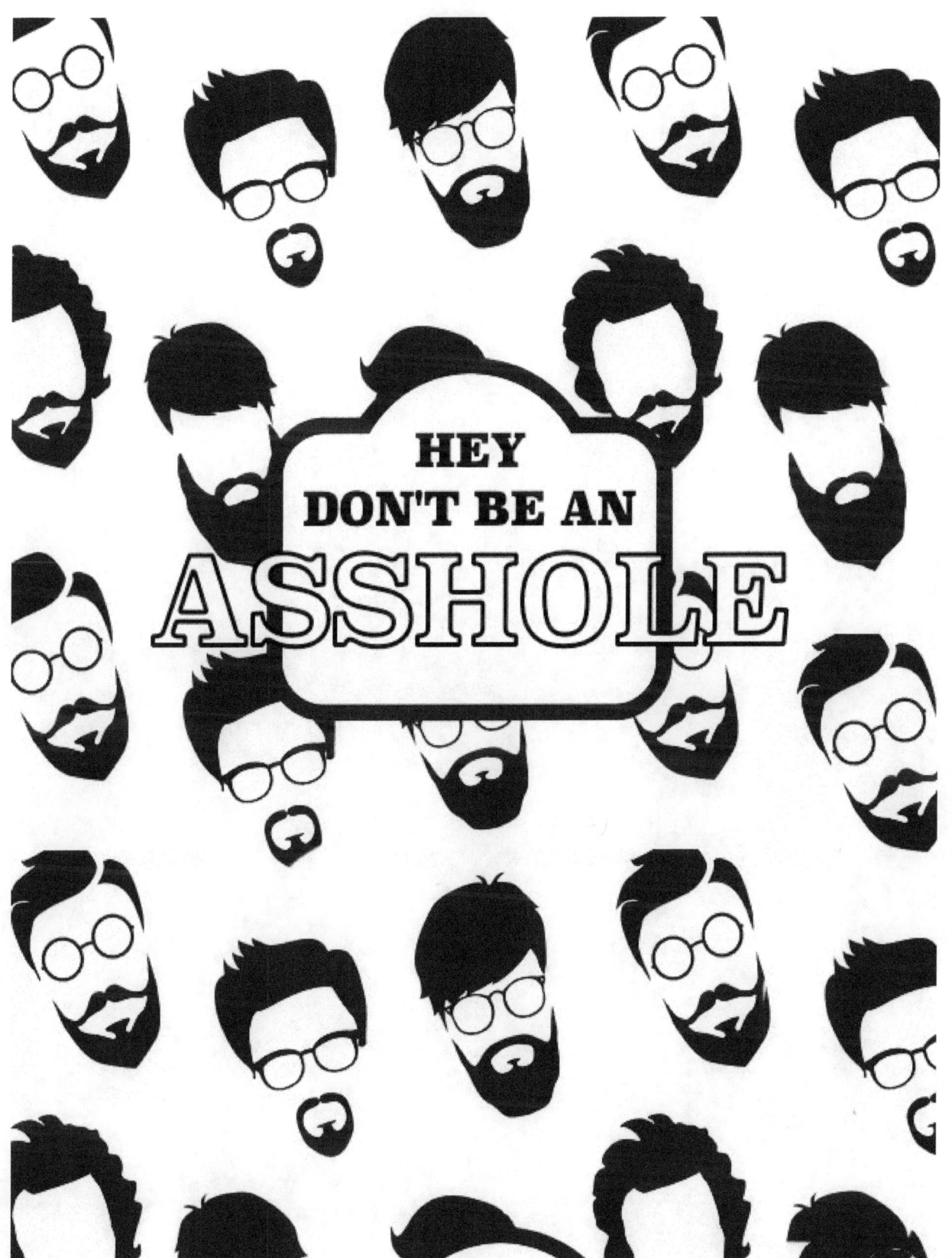

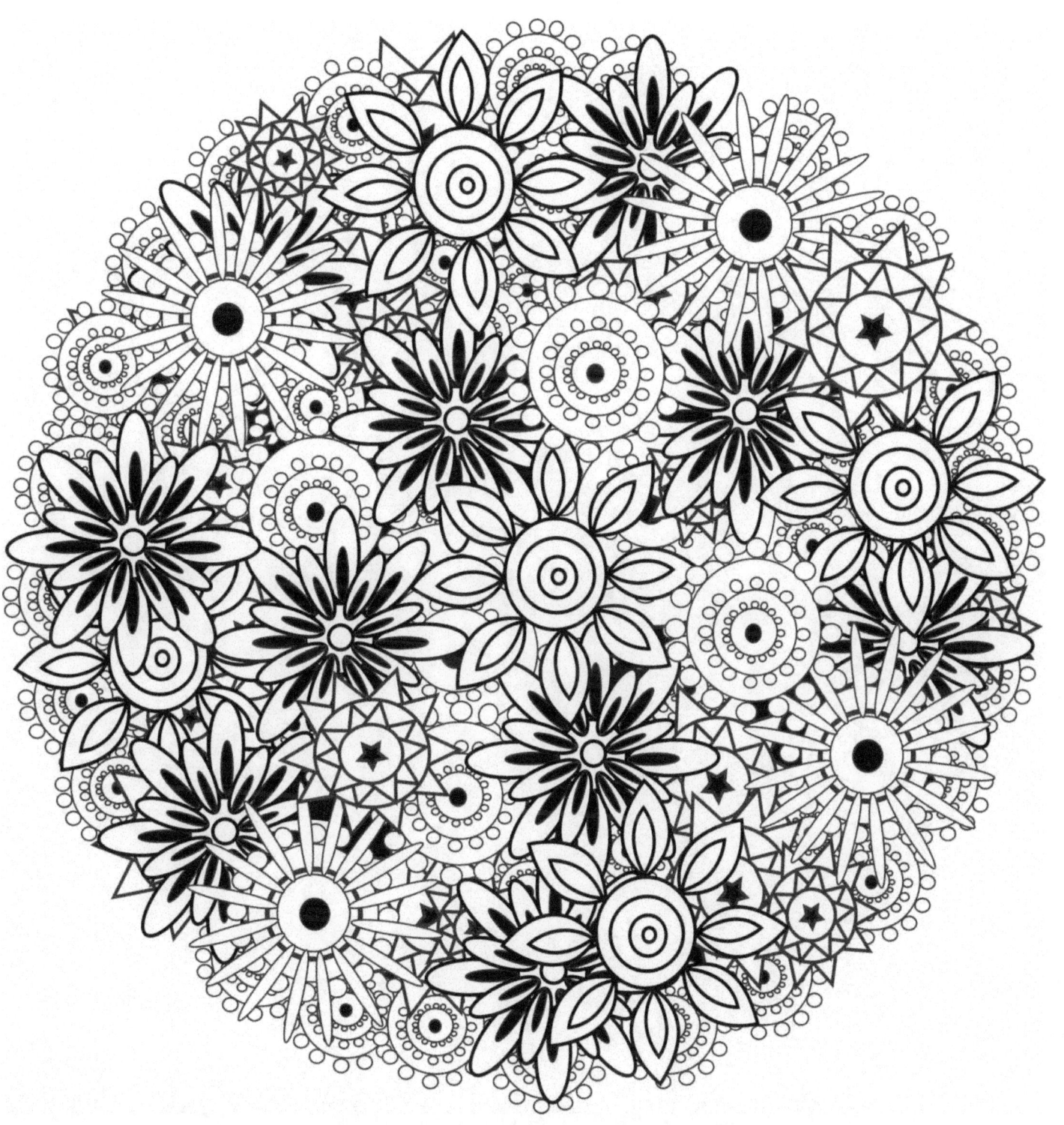

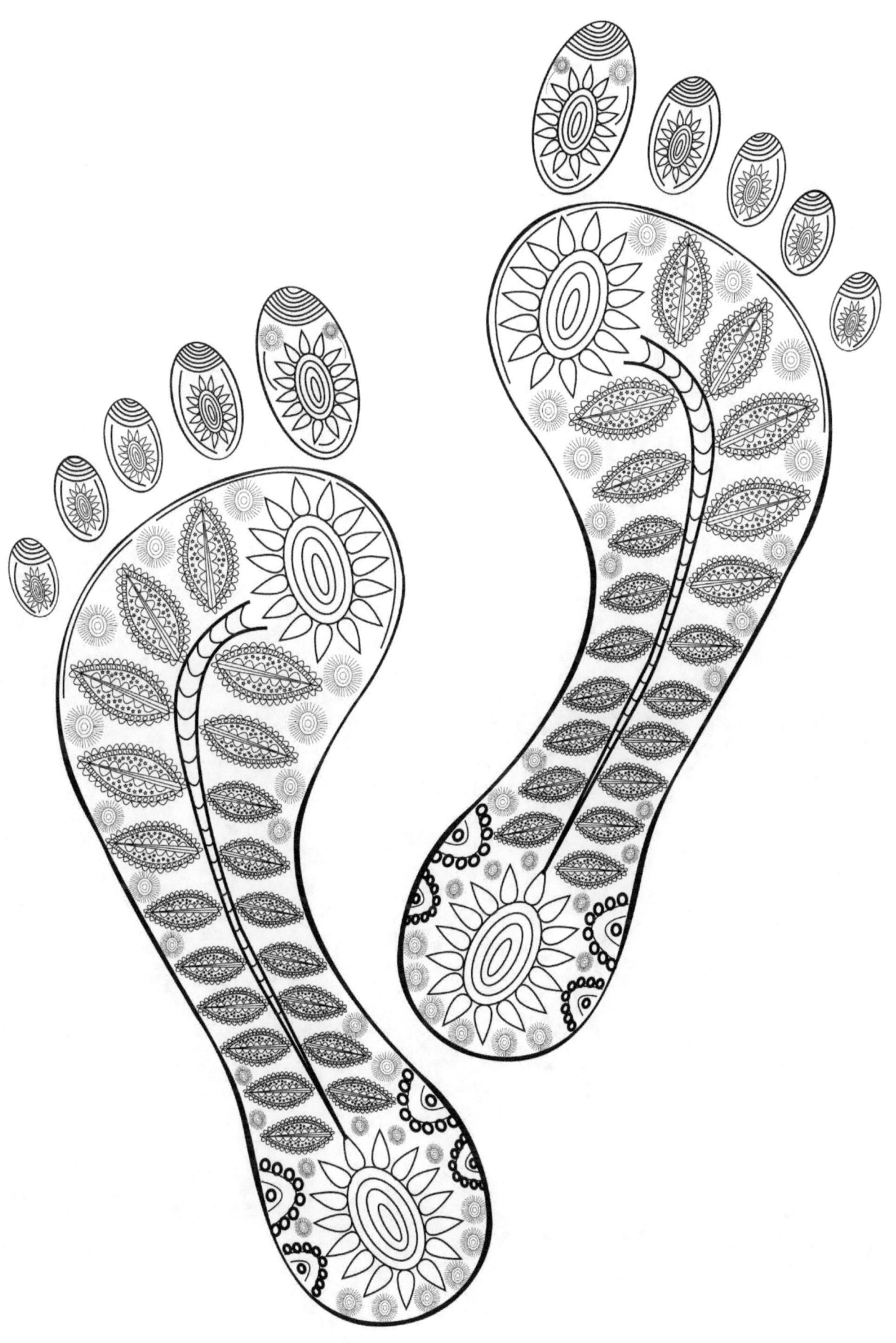

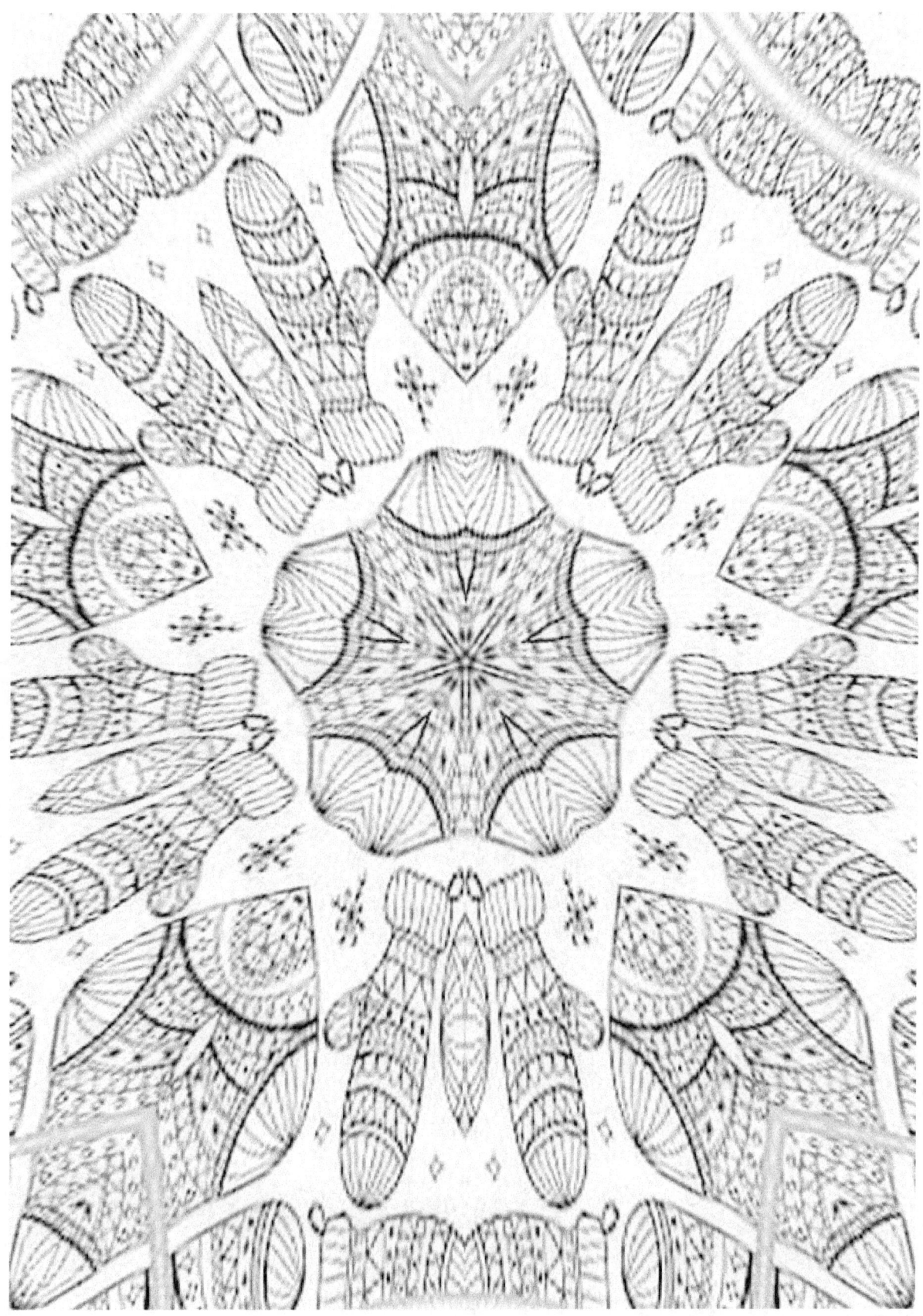

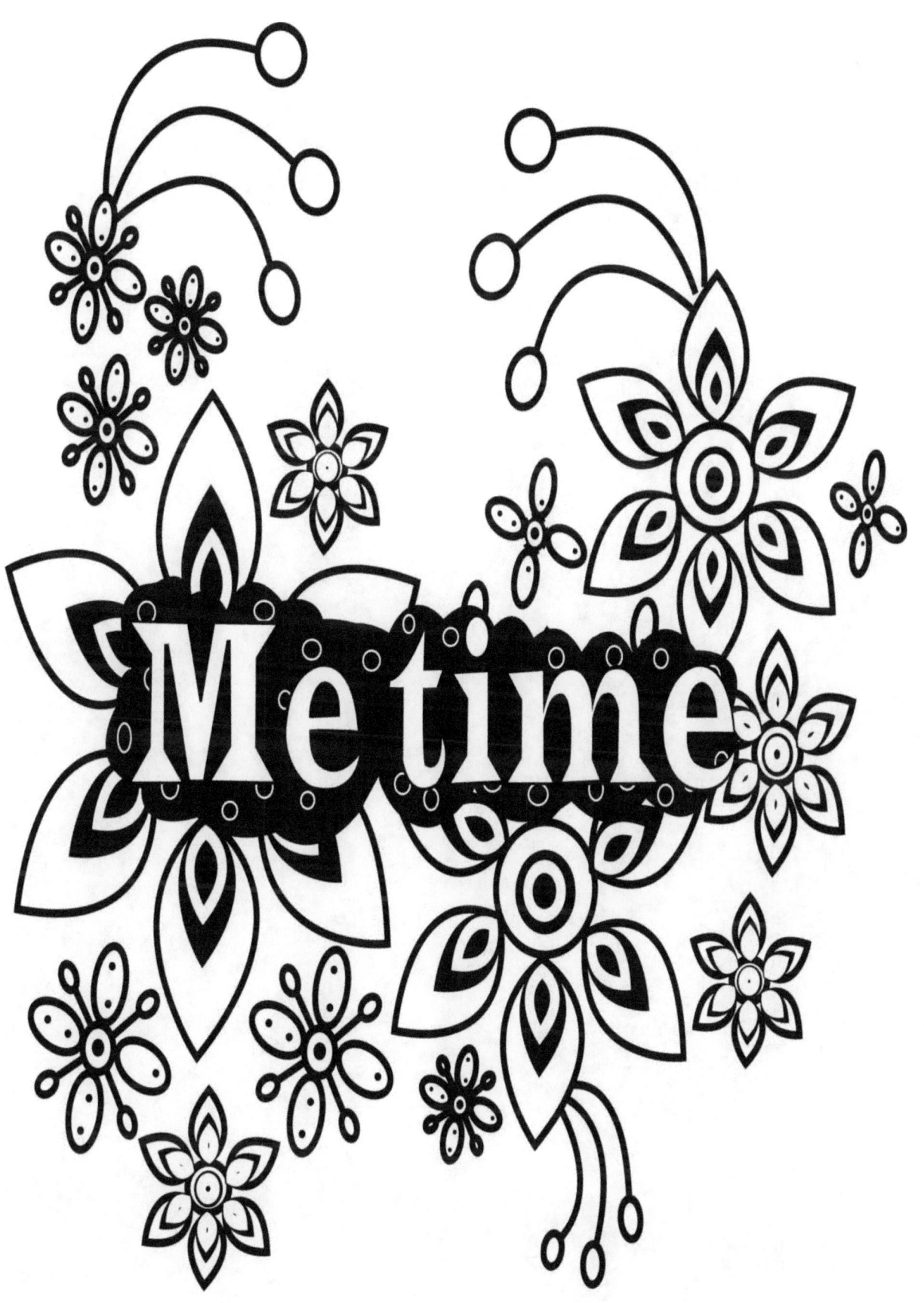

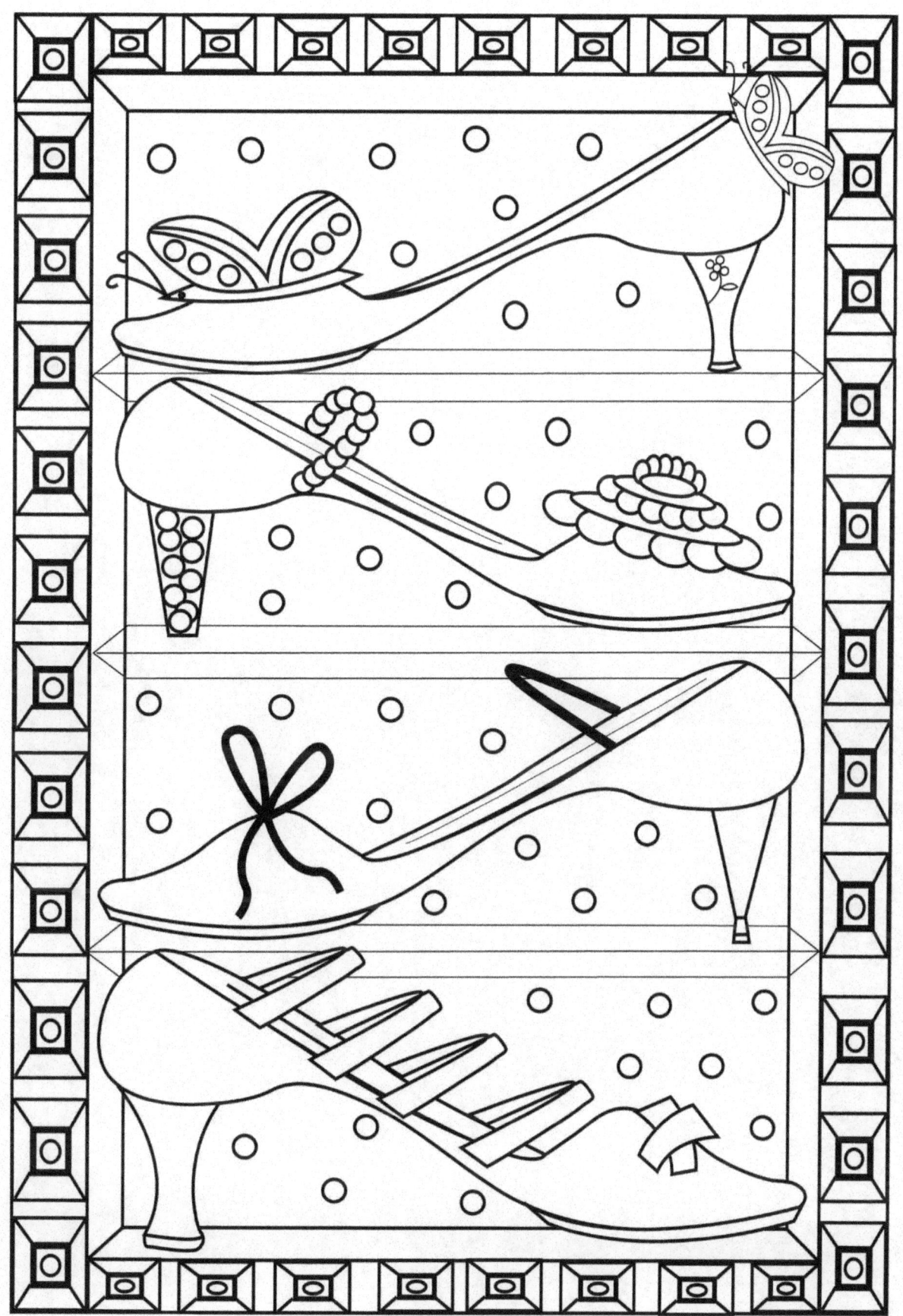

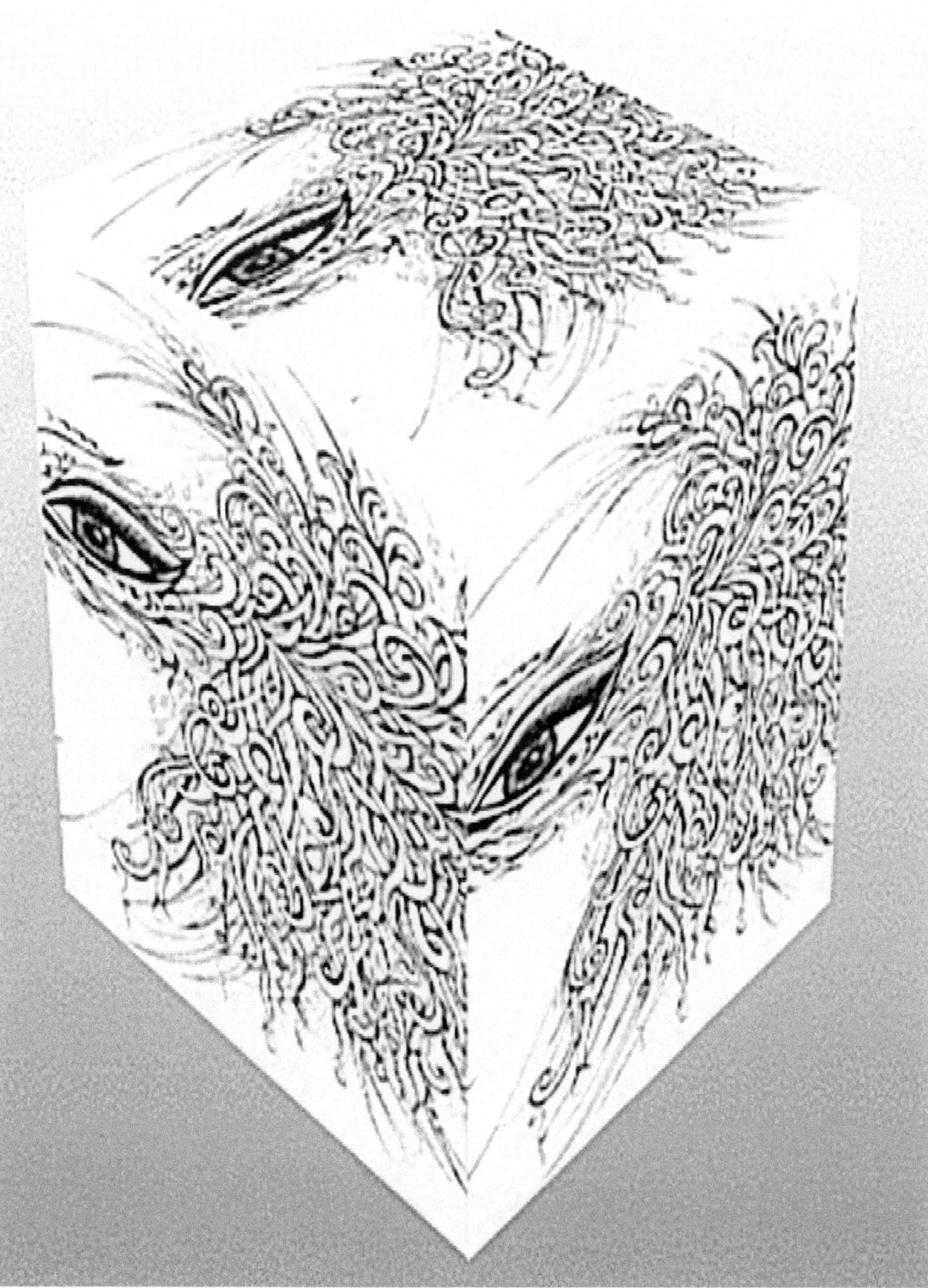

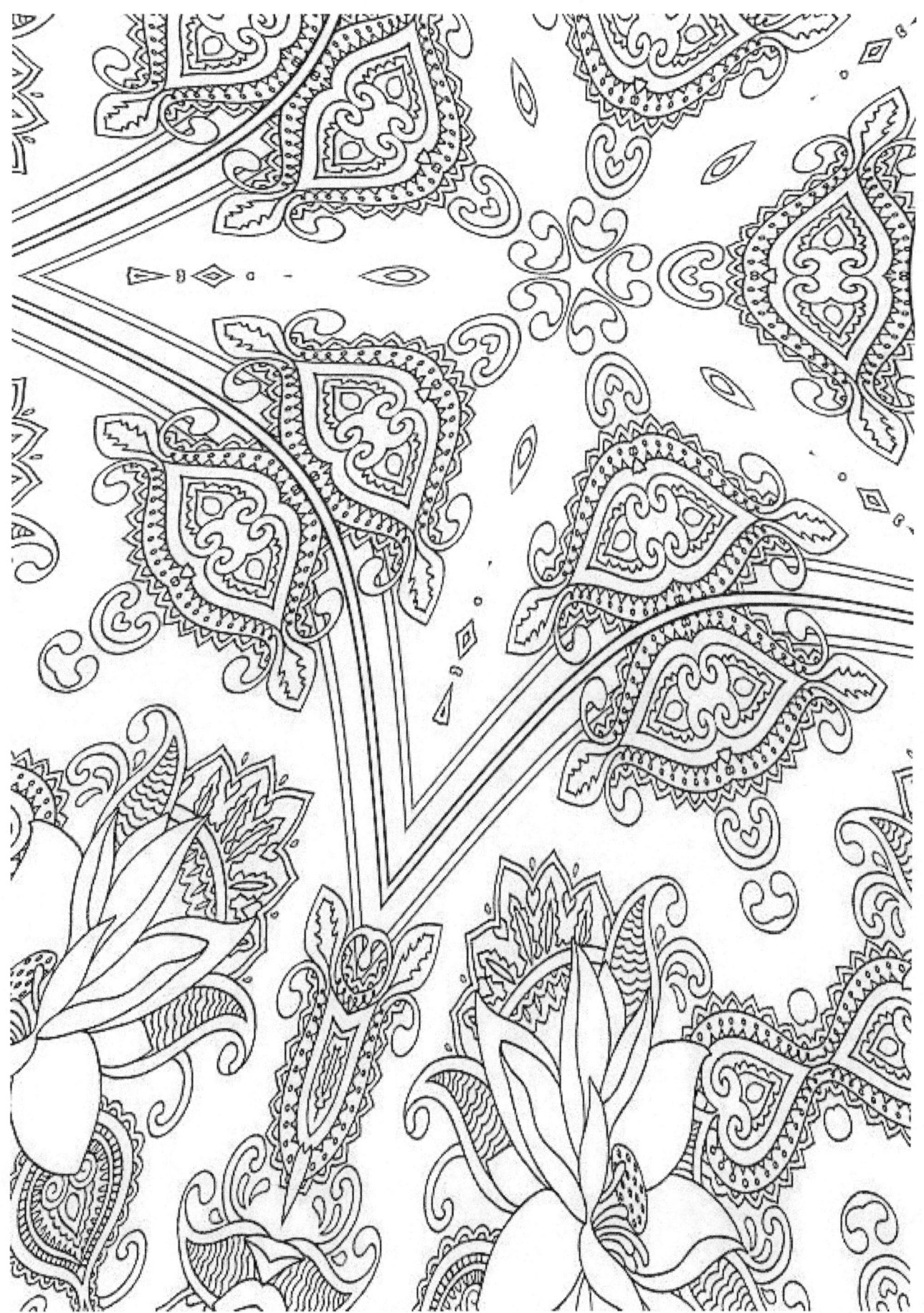

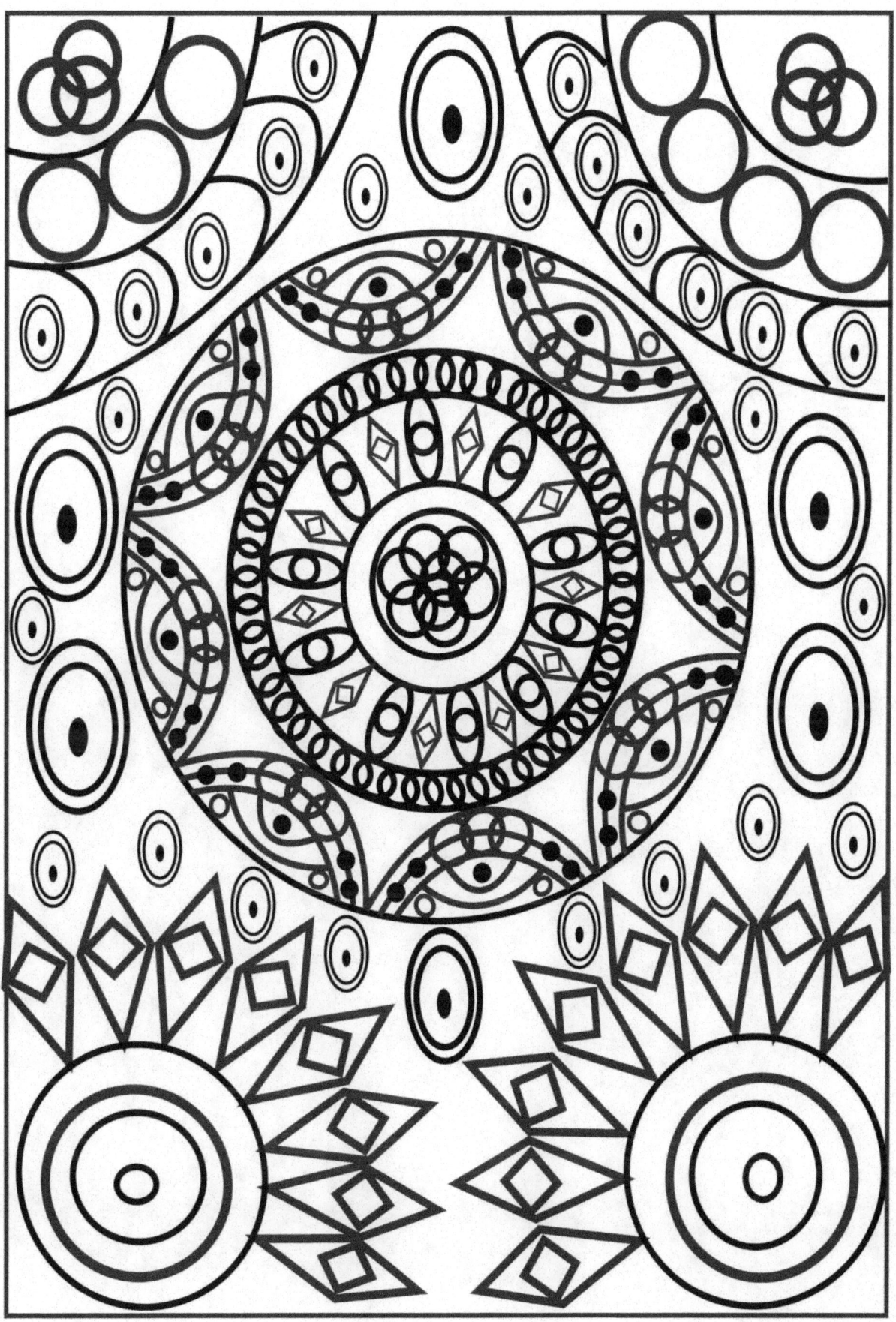

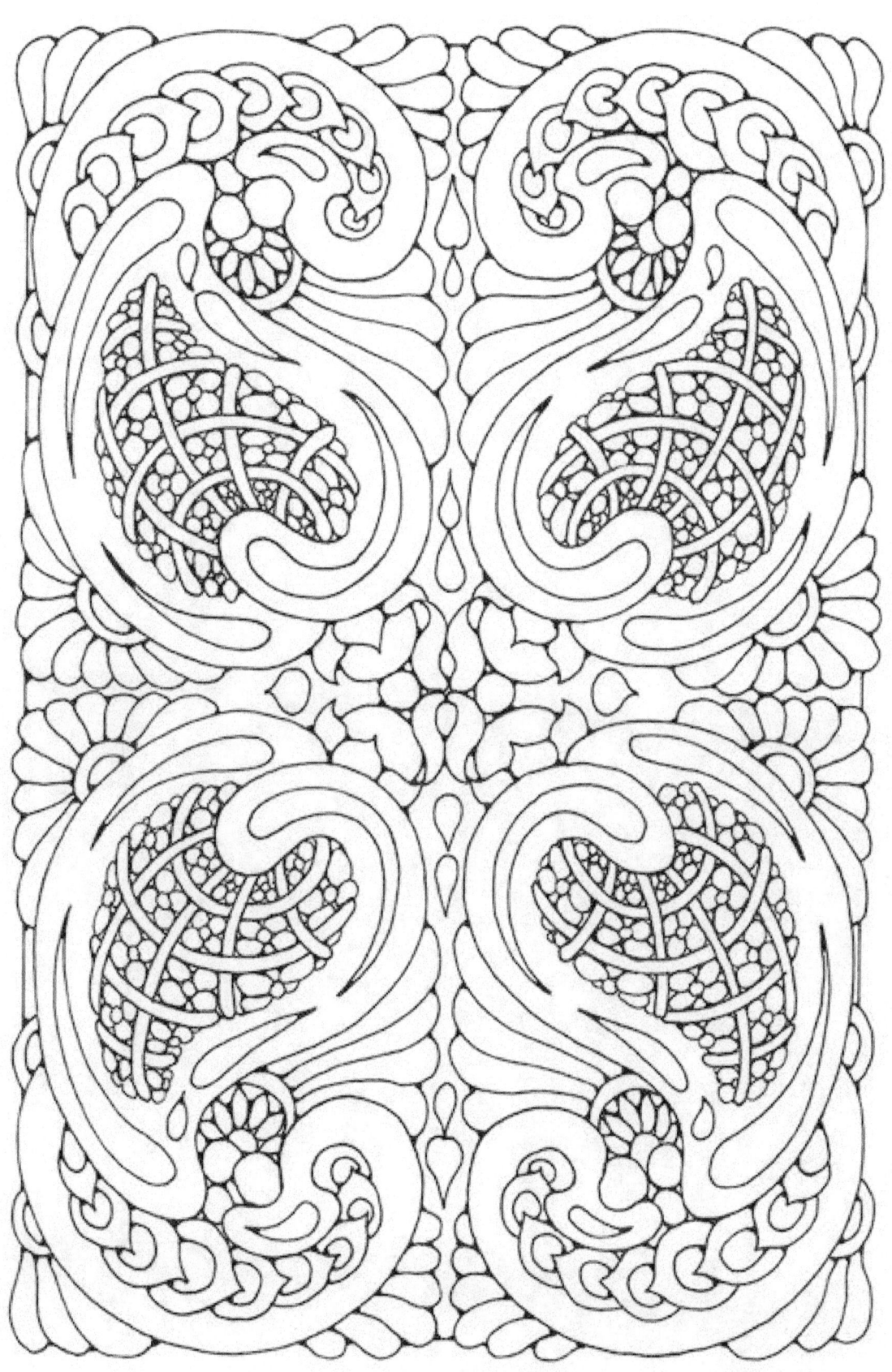

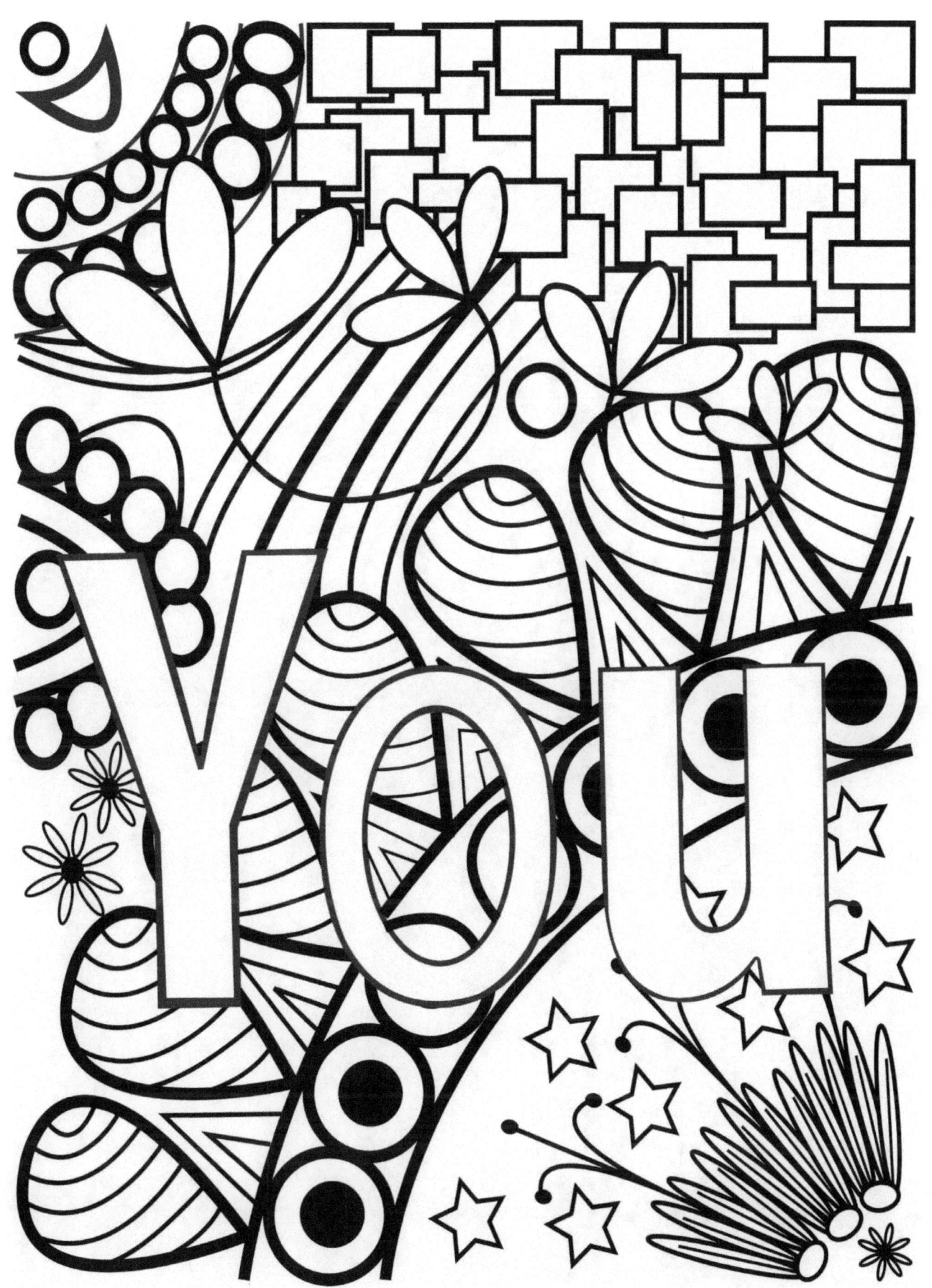

Please leave a review and pictures of the pages you have colored.

Go to amazon.com and type in America Selby to find my books.

Enjoy some other books.

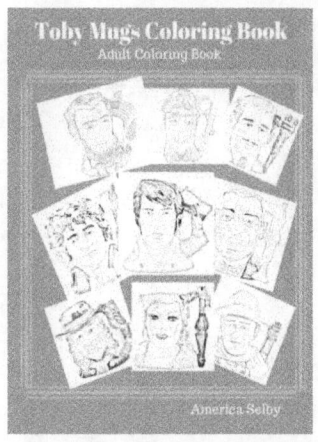
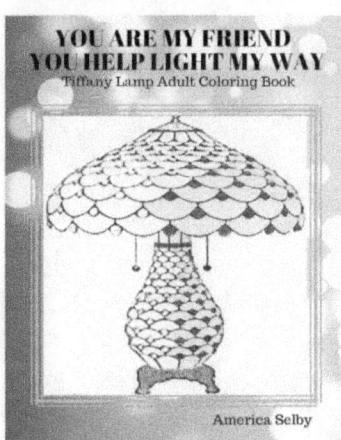
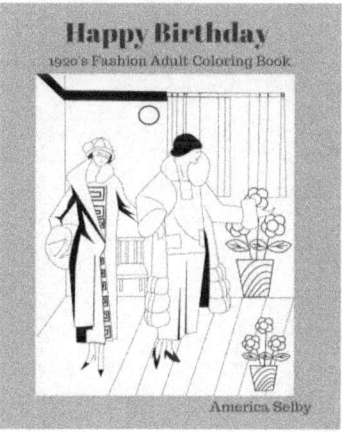

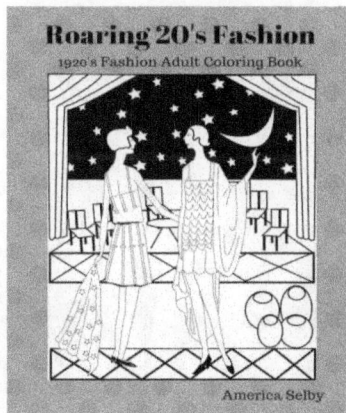

www.ingramcontent.com/pod-product-compliance
Lightning Source LLC
Chambersburg PA
CBHW080707190526
45169CB00006B/2284